Face Tattoo copyright© 2016 by John Riegert

http://www.johnriegert.com
john@Johnriegert.com

First Edition, First Printing

ISBN: 978-1-365-10144-1

Do not brood over your past mistakes and failures as this will only fill your mind with grief, regret and depression. Do not repeat them in the future.
~ Swami Sivananda

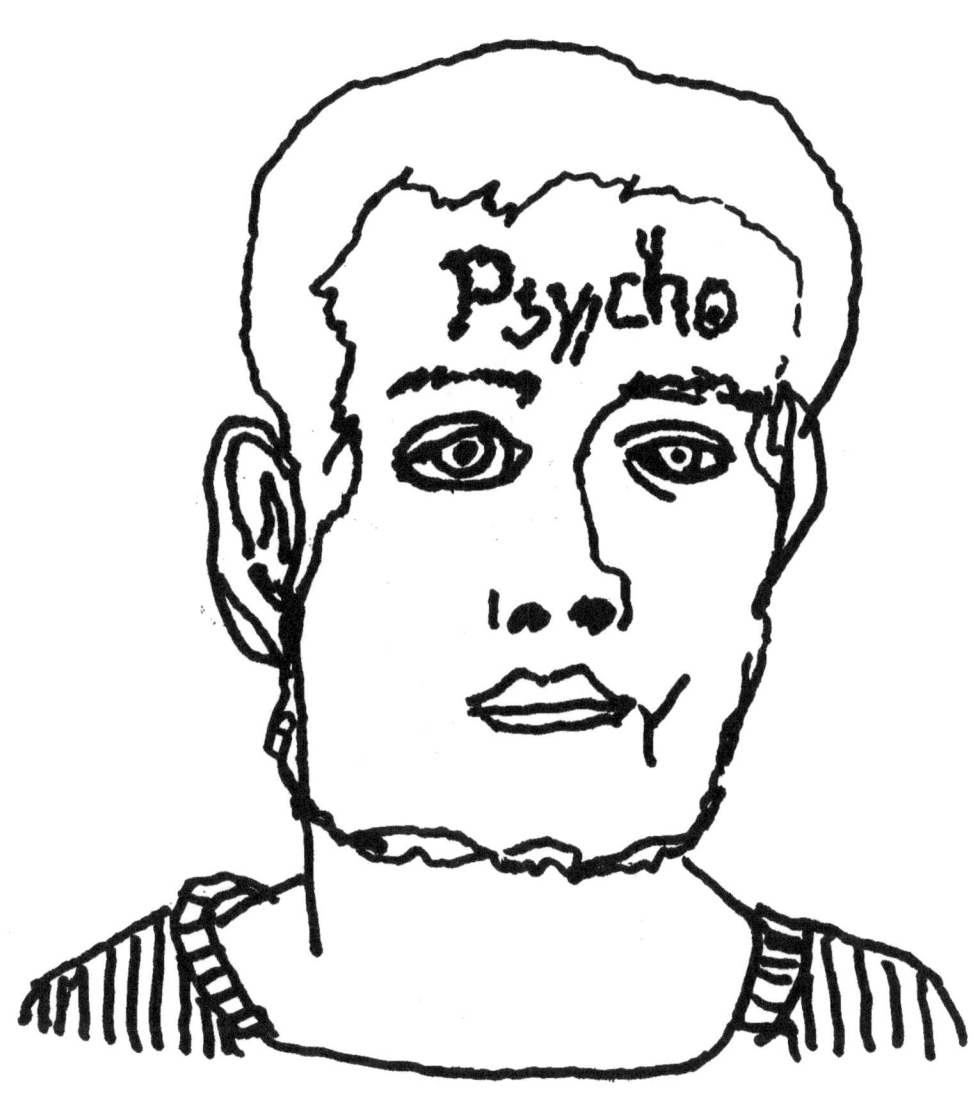

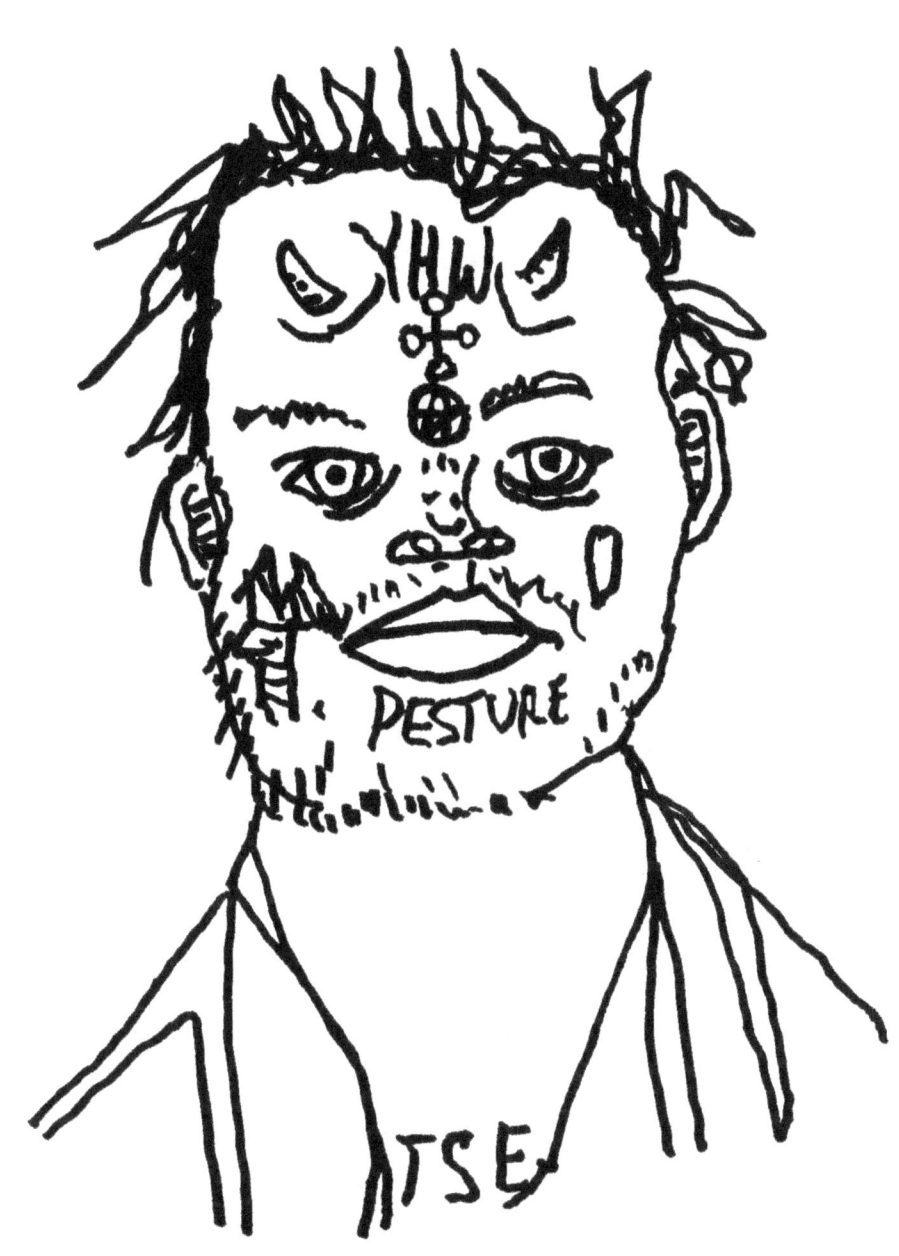

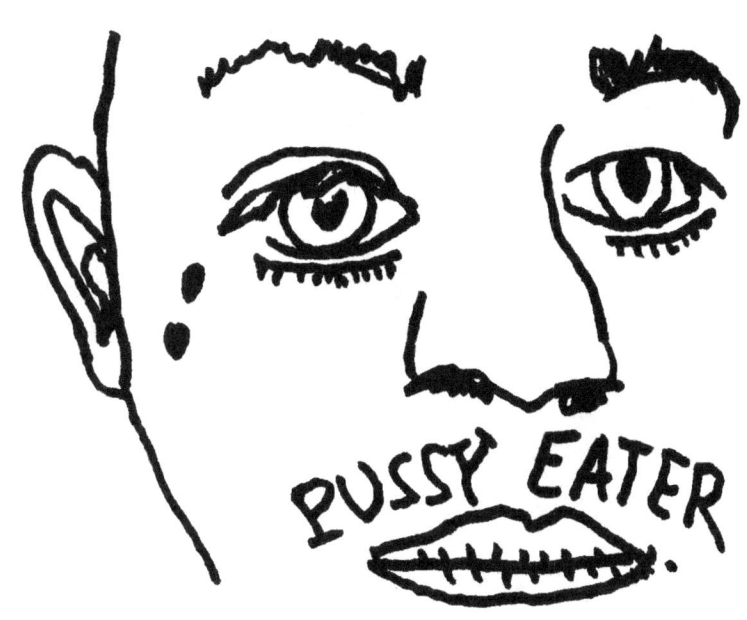

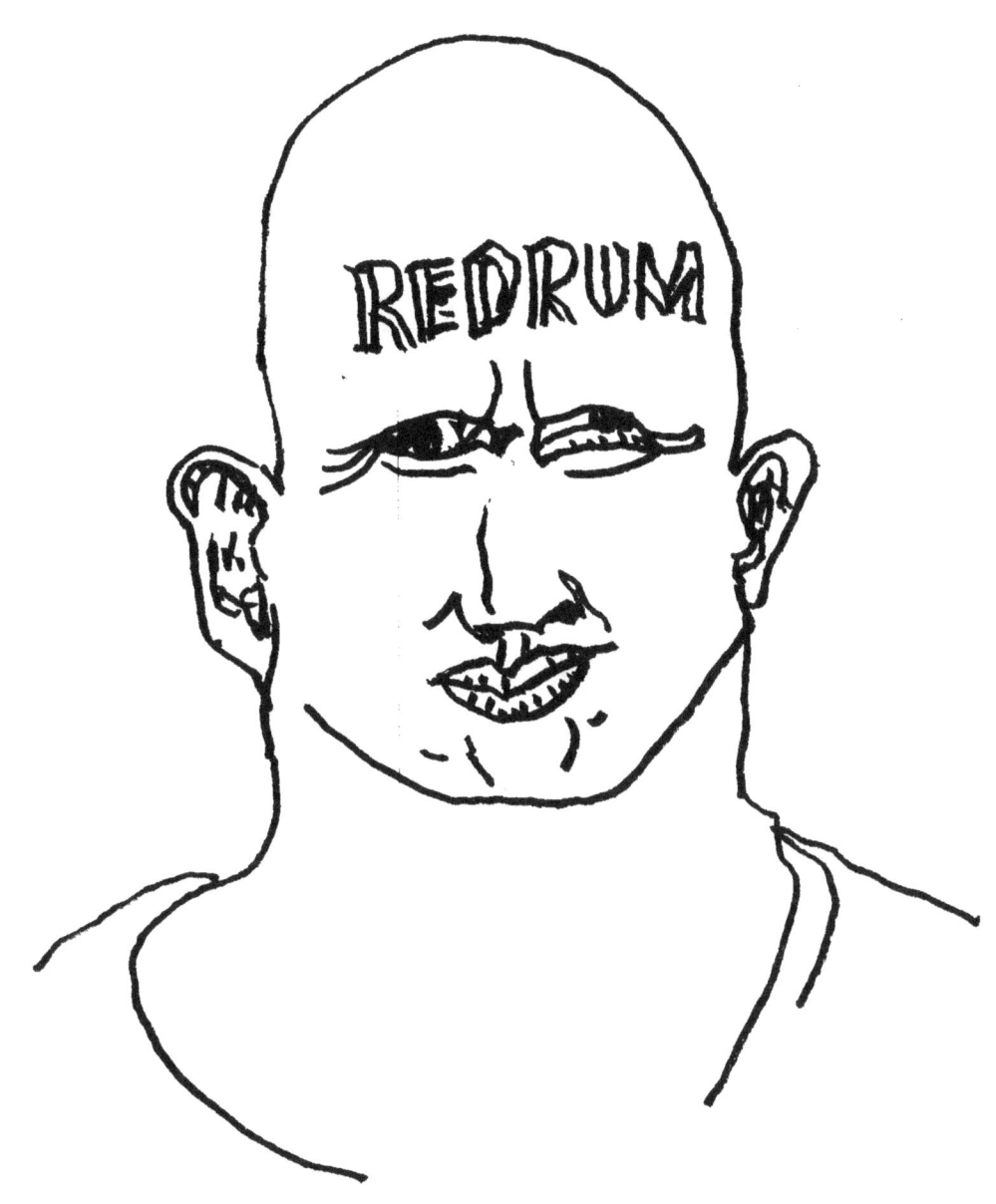

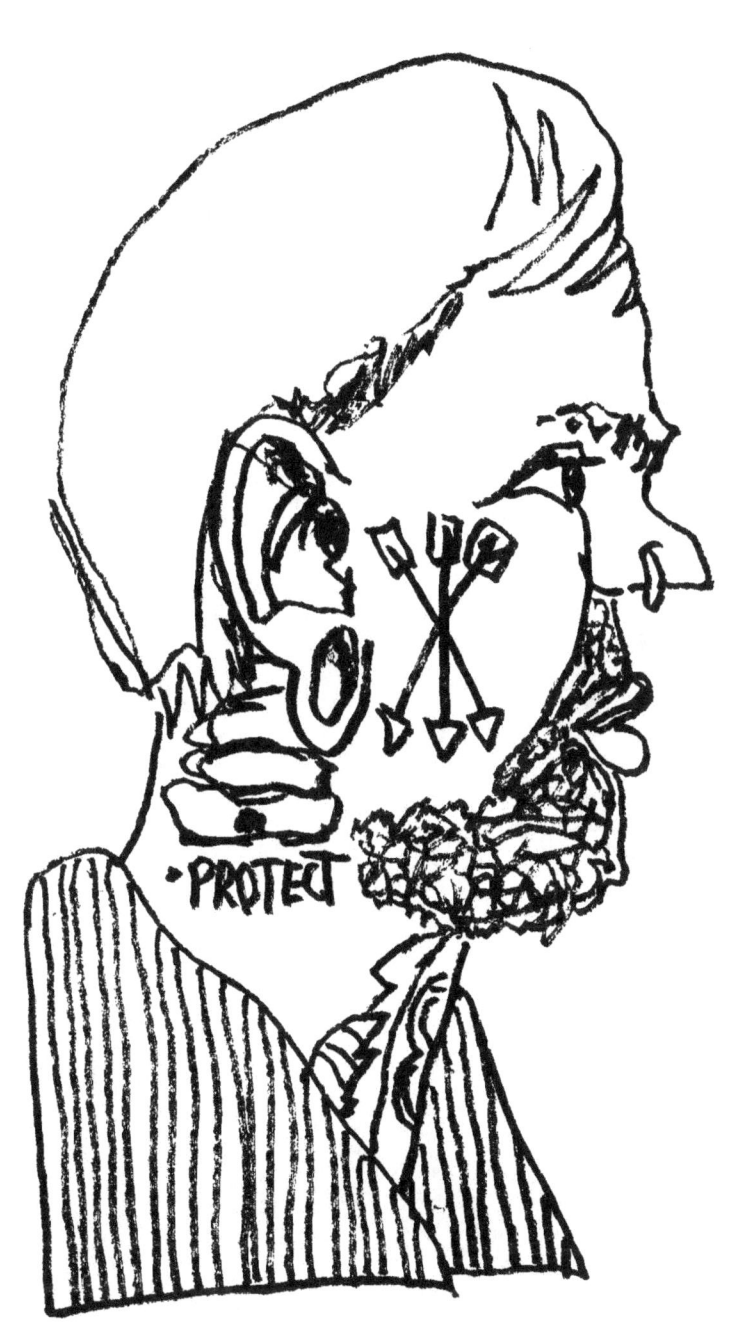

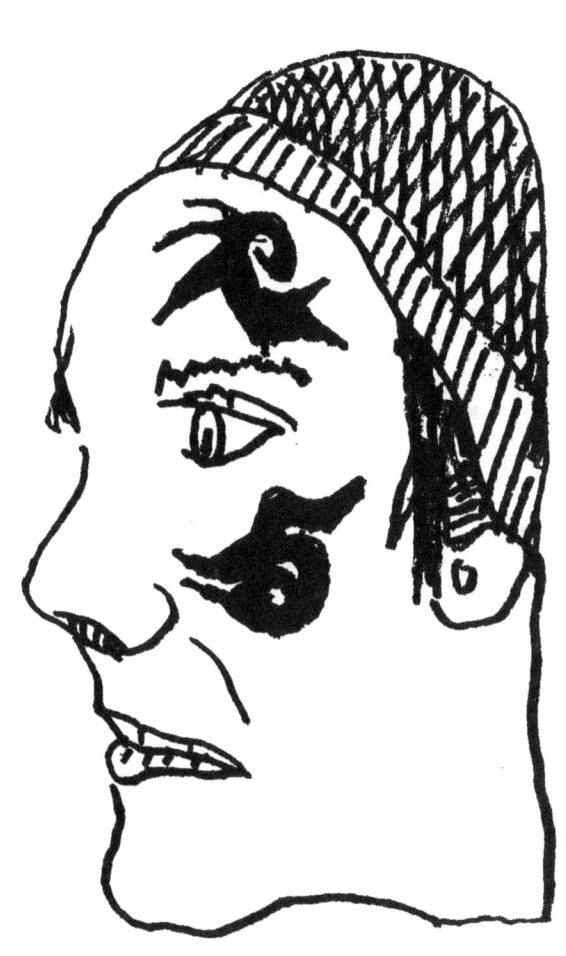

Florida Tattoo

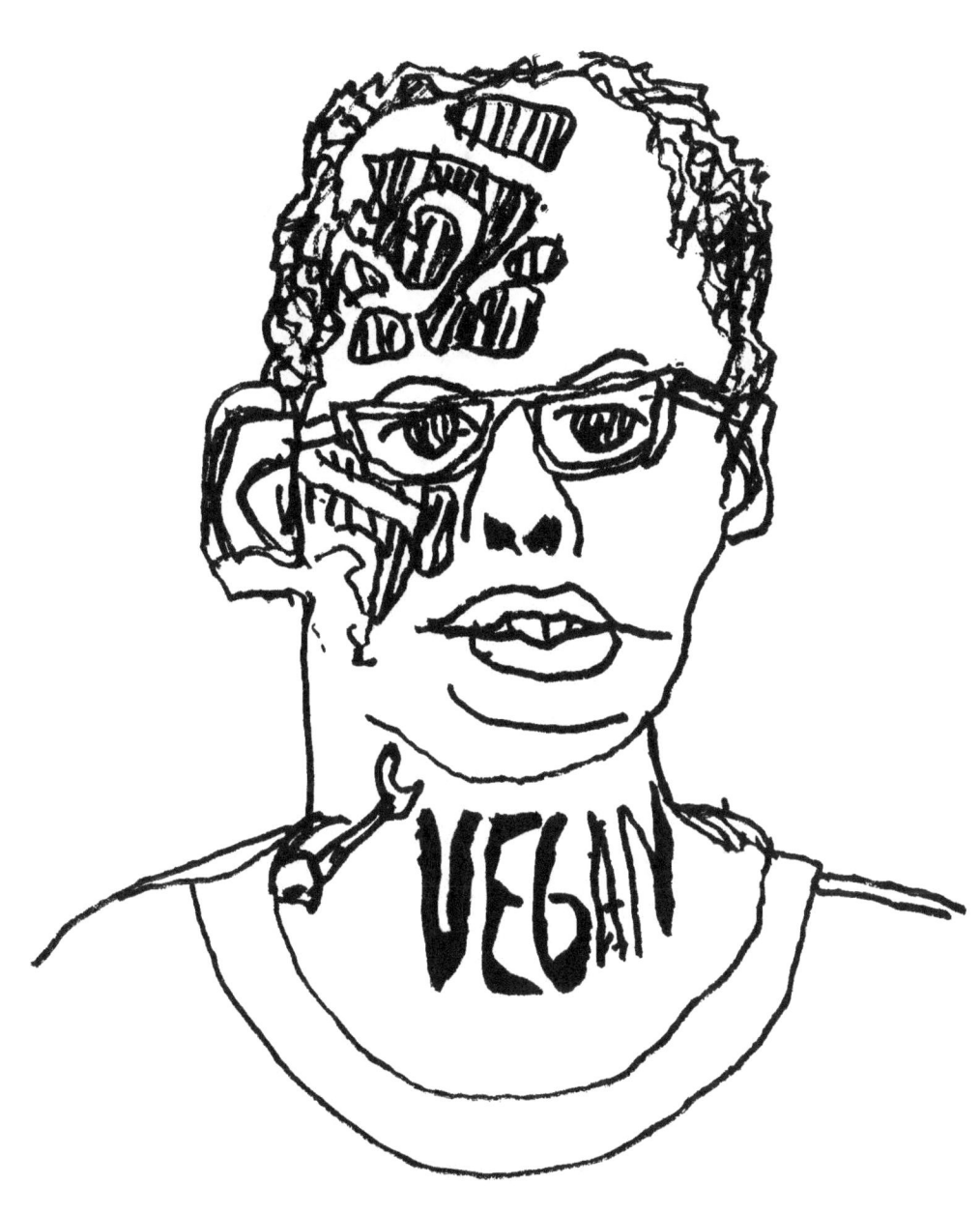

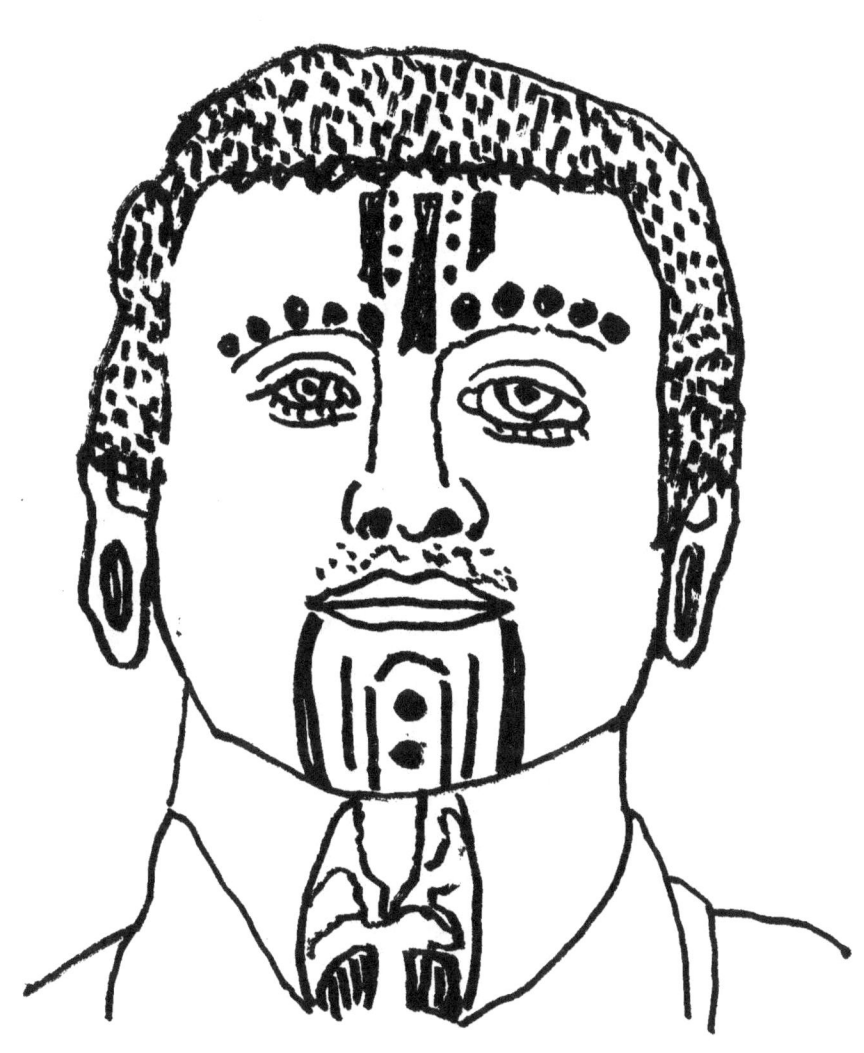

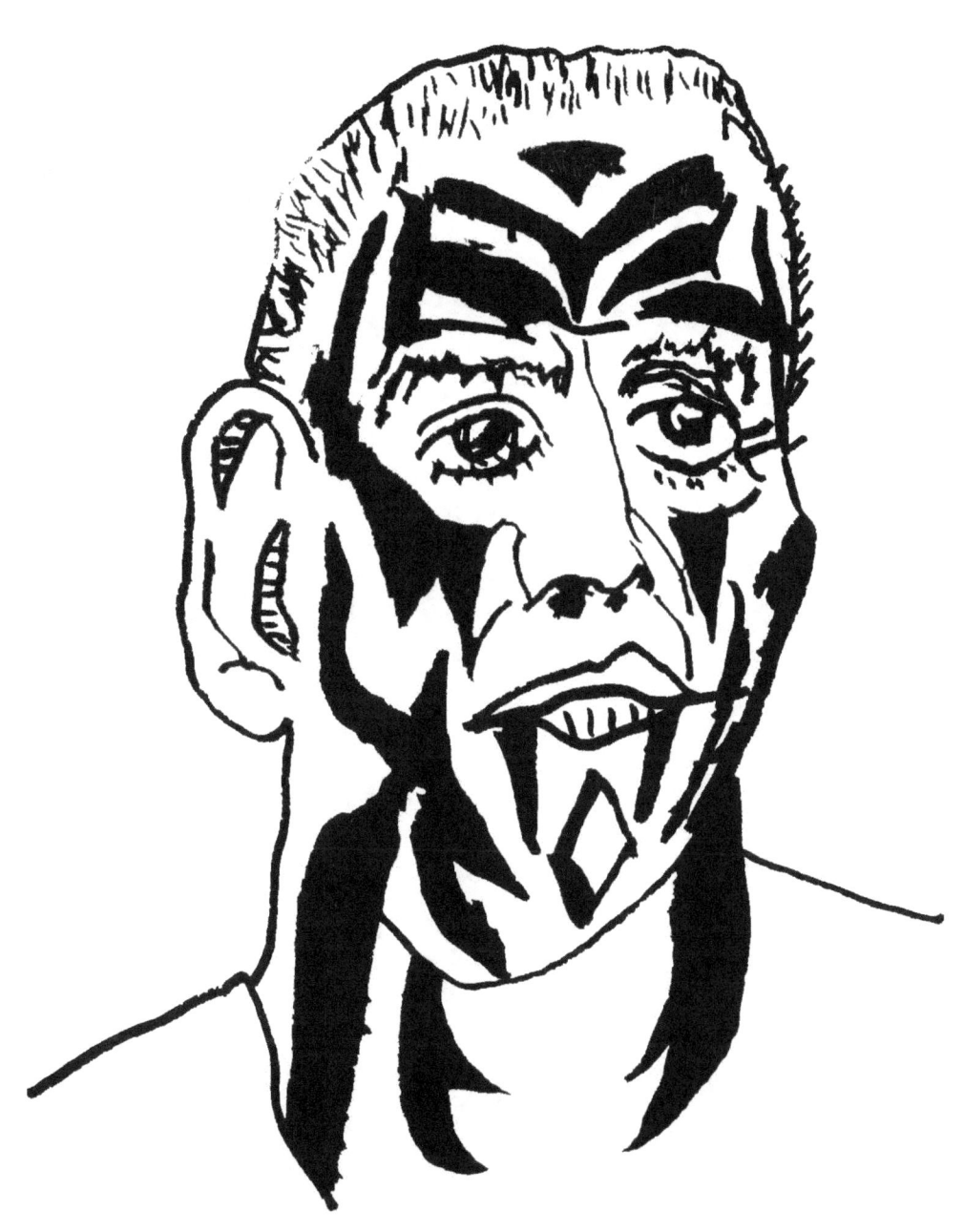

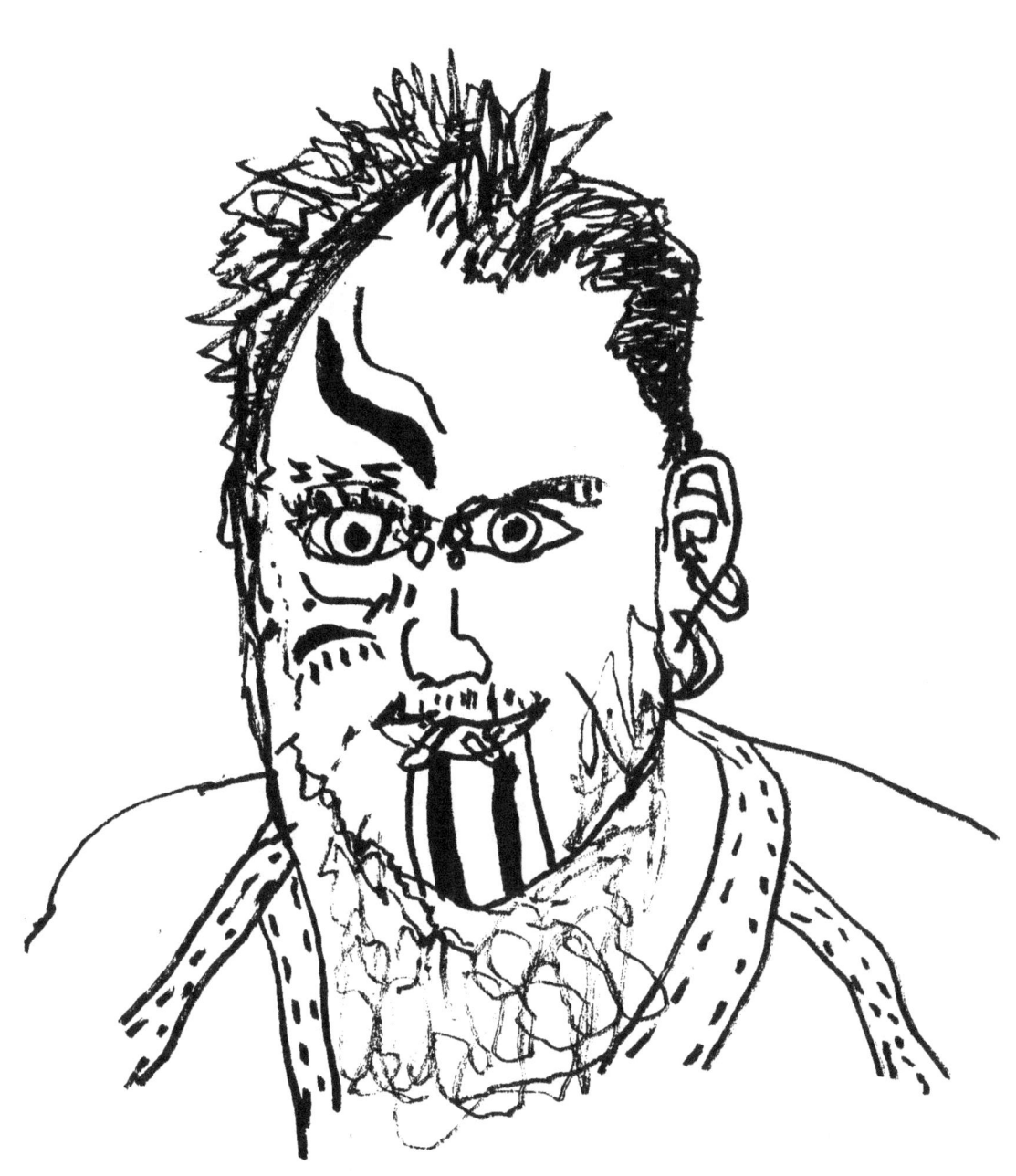

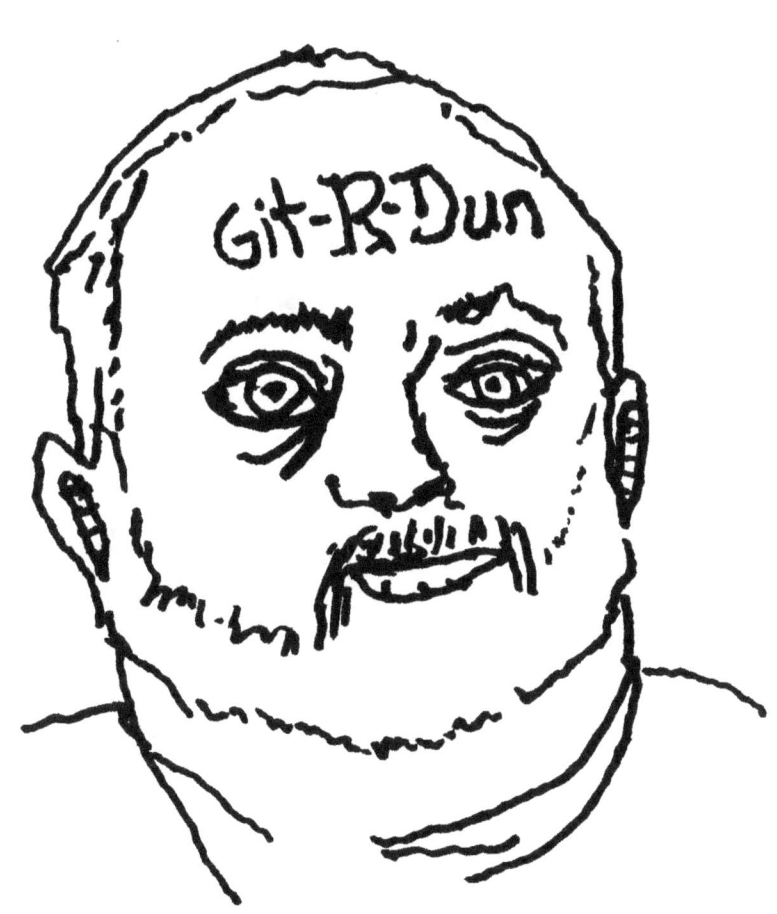

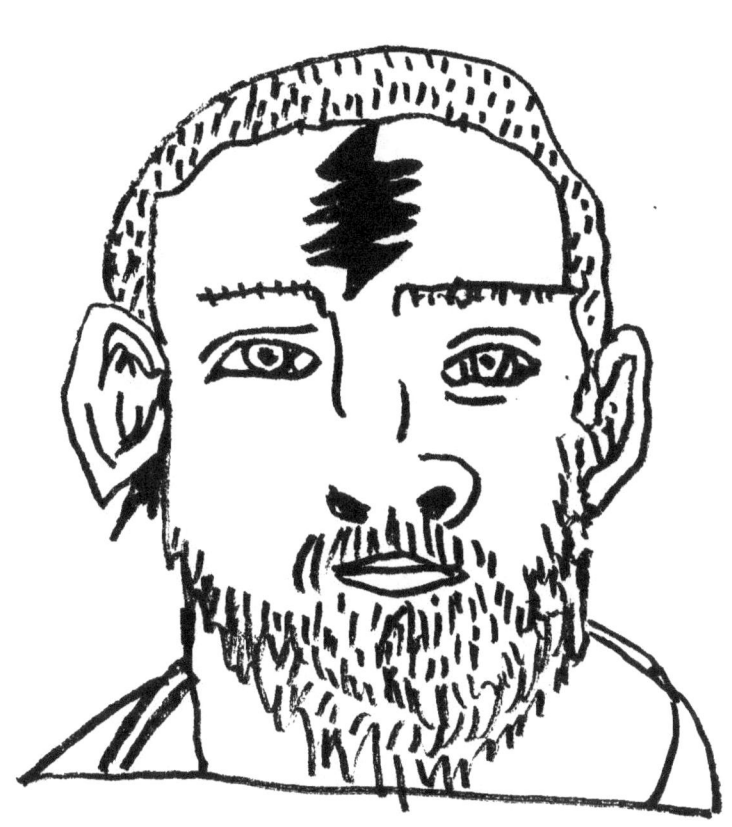

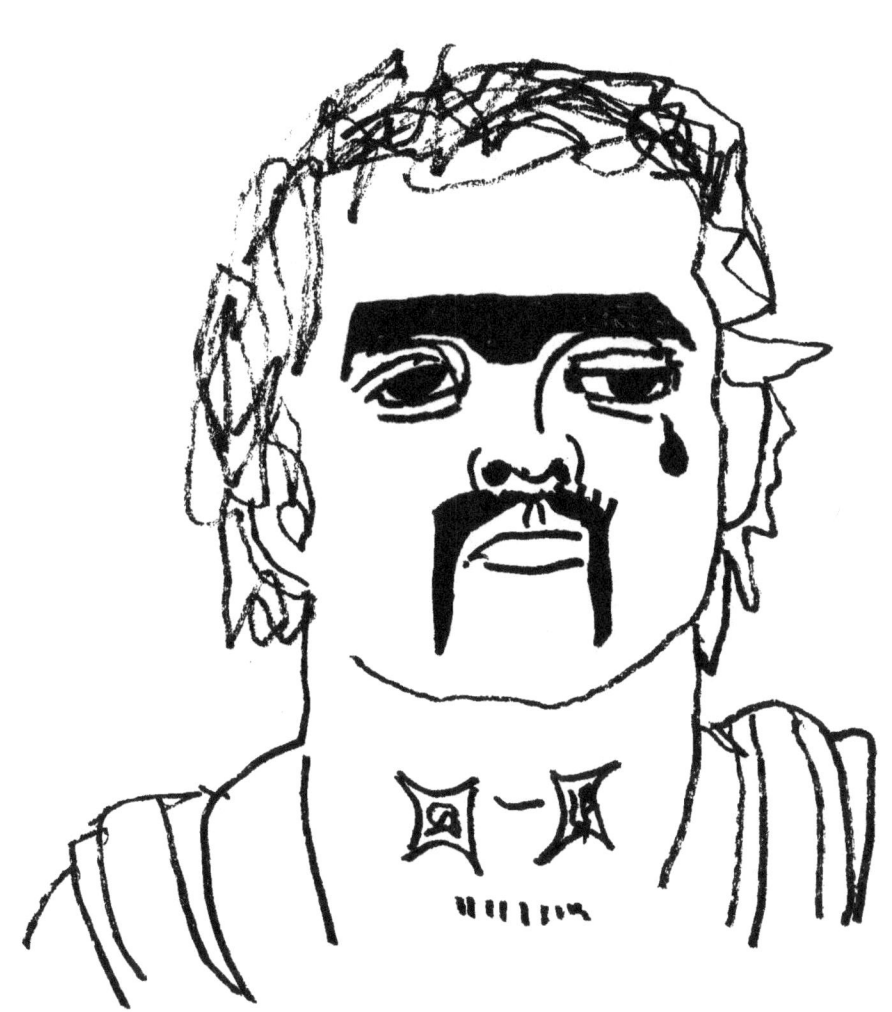

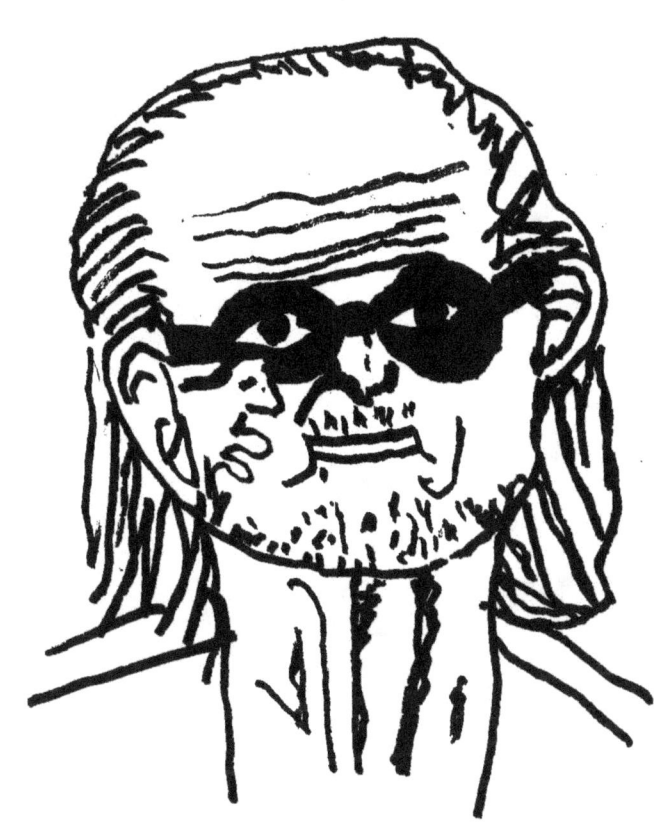

Eye Glasses

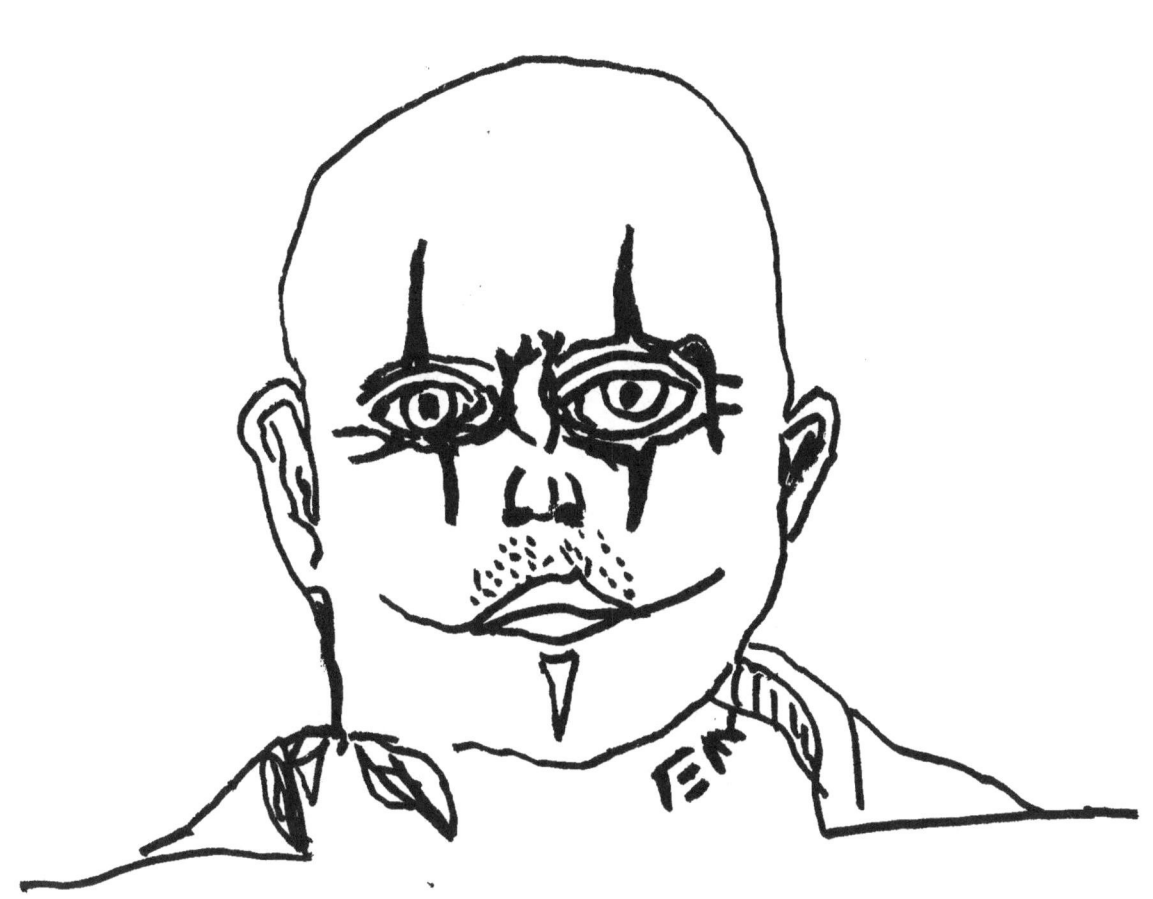

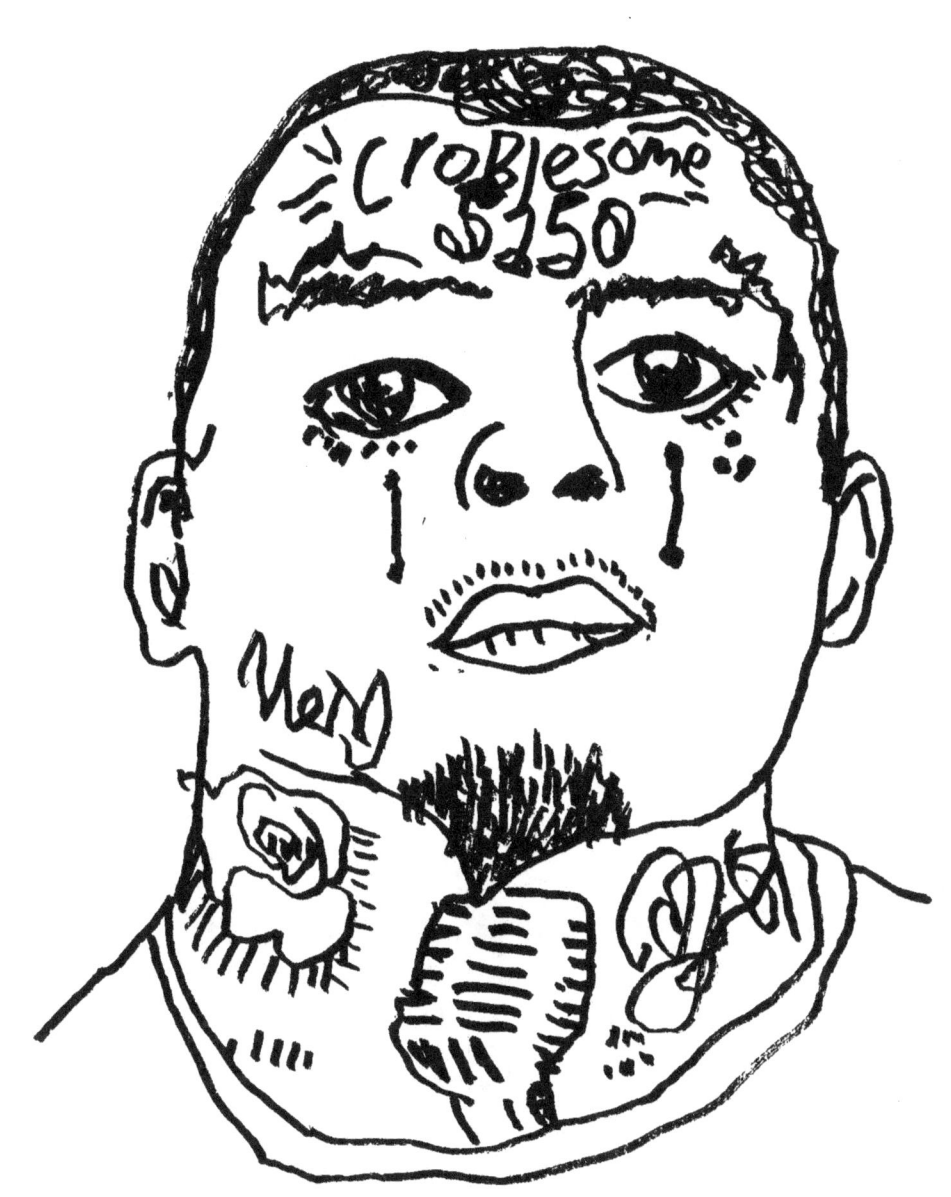

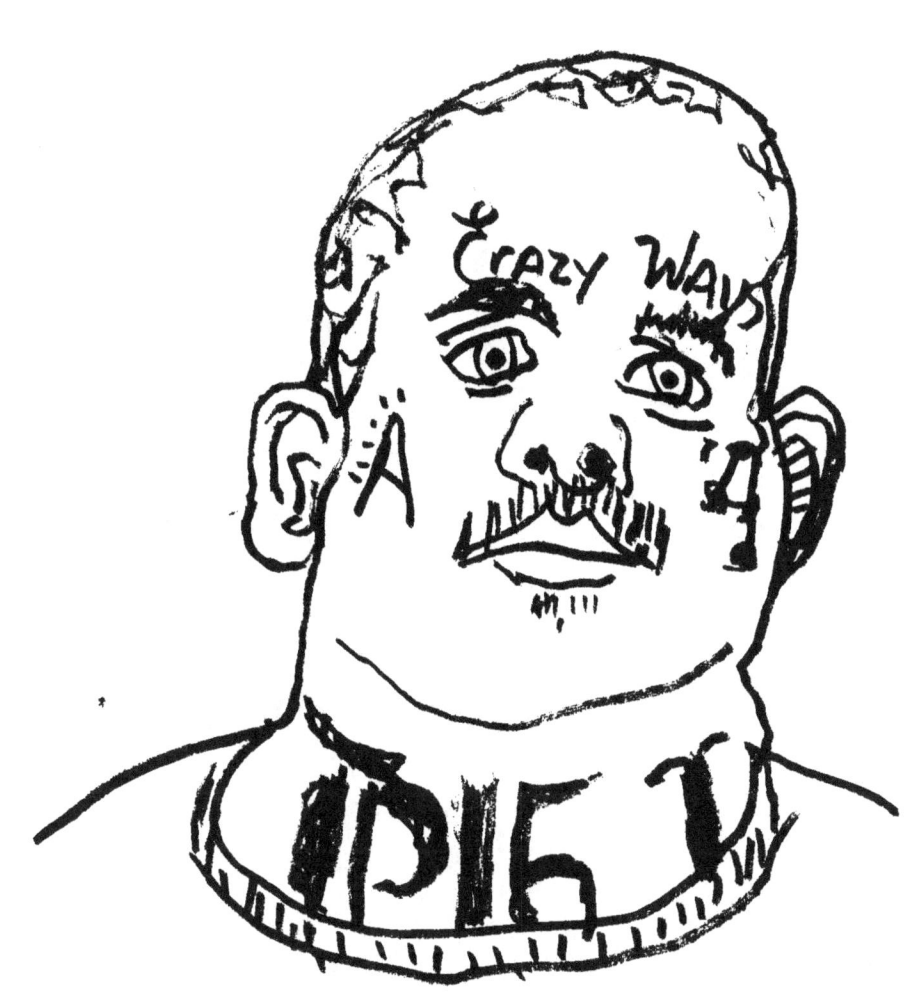

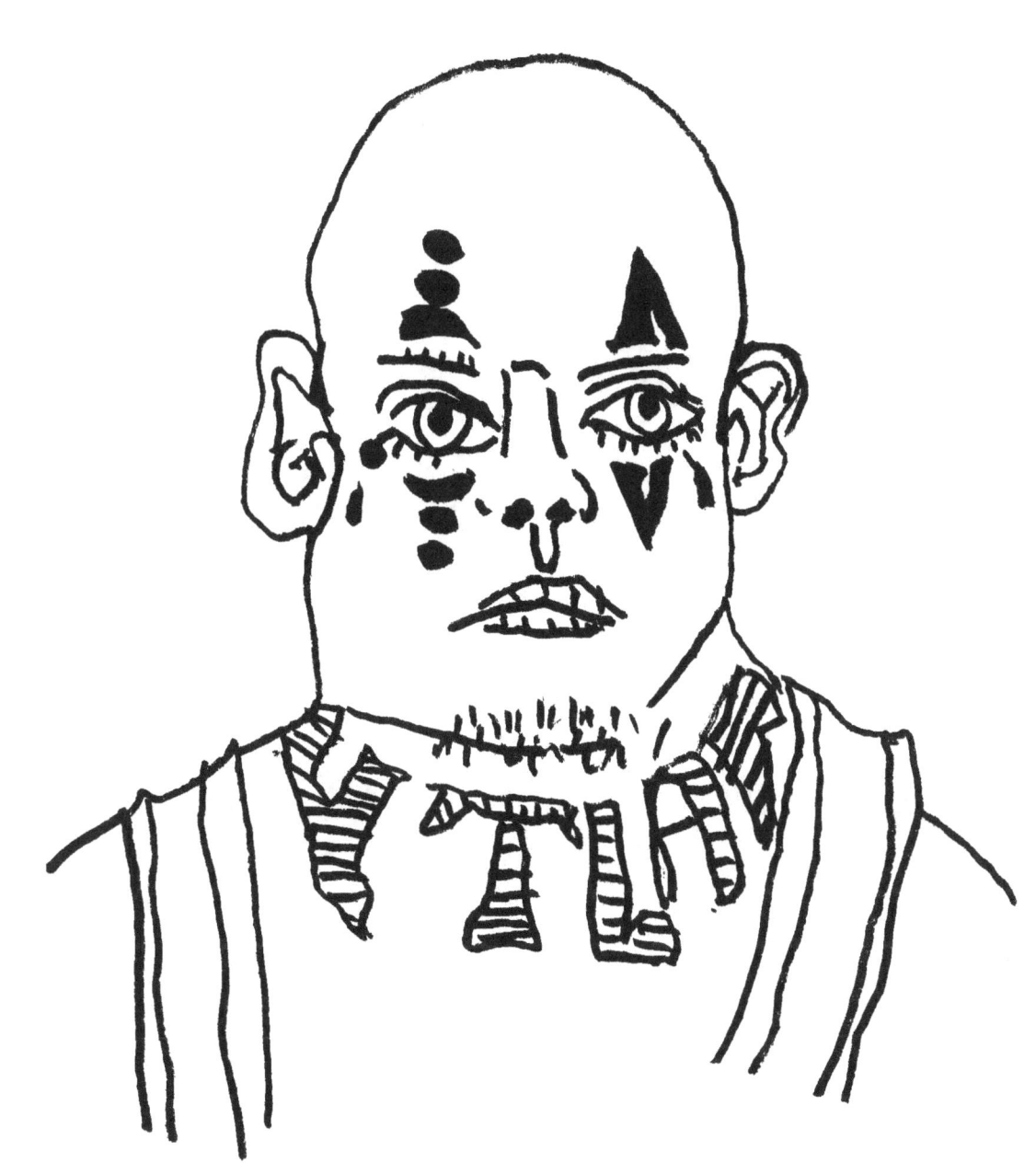

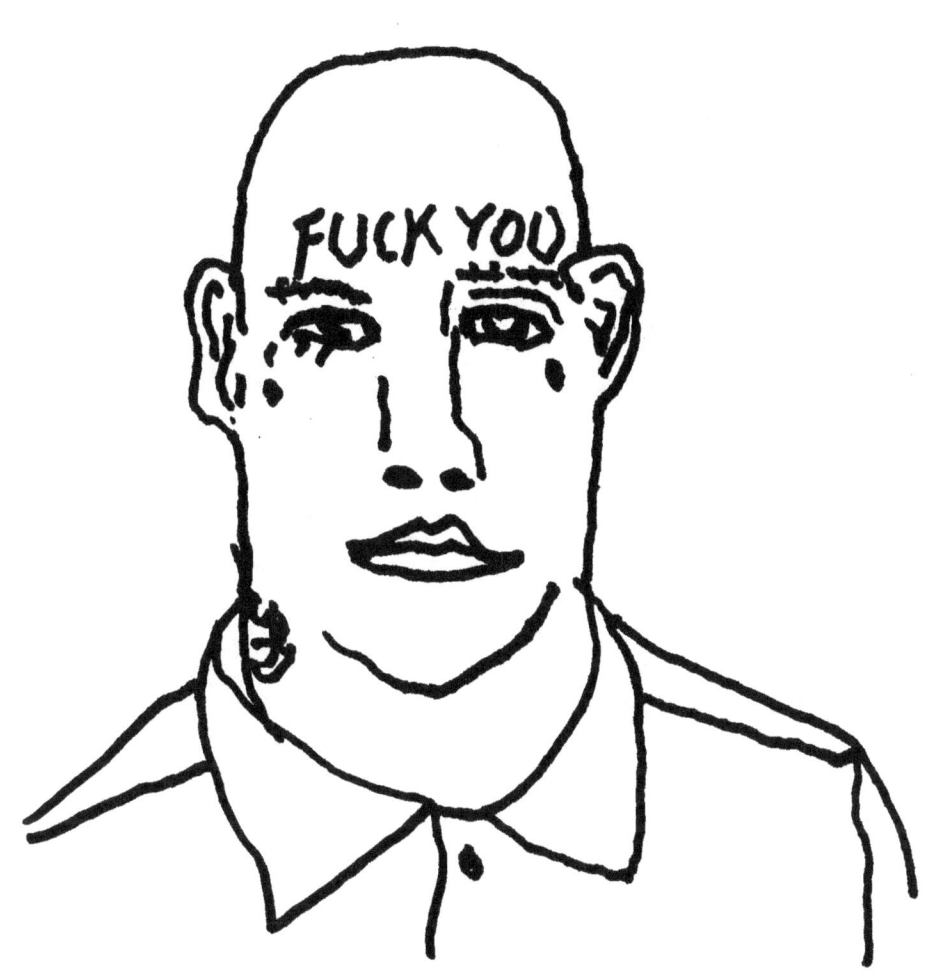

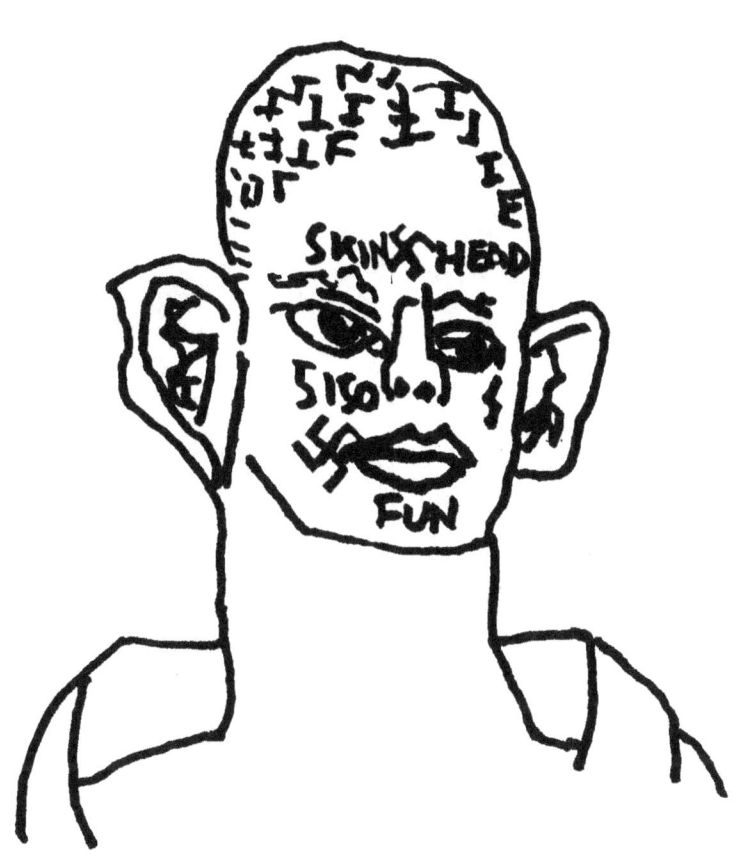

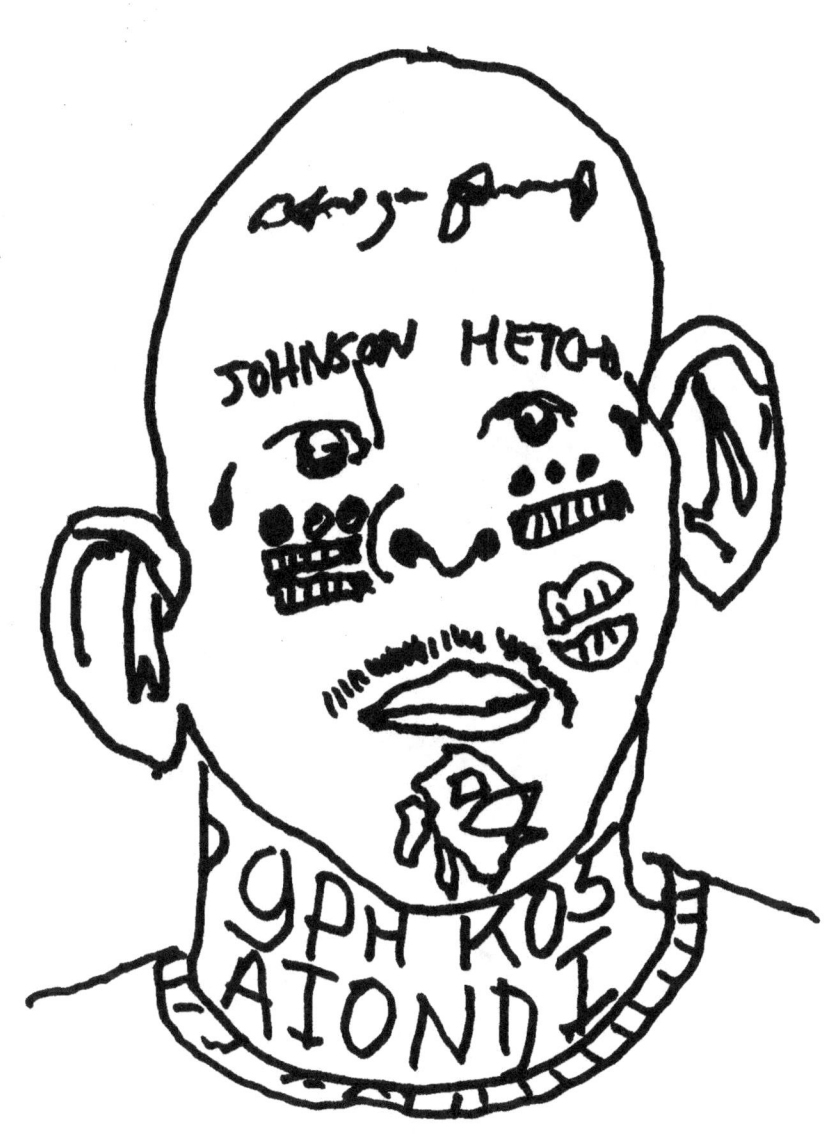

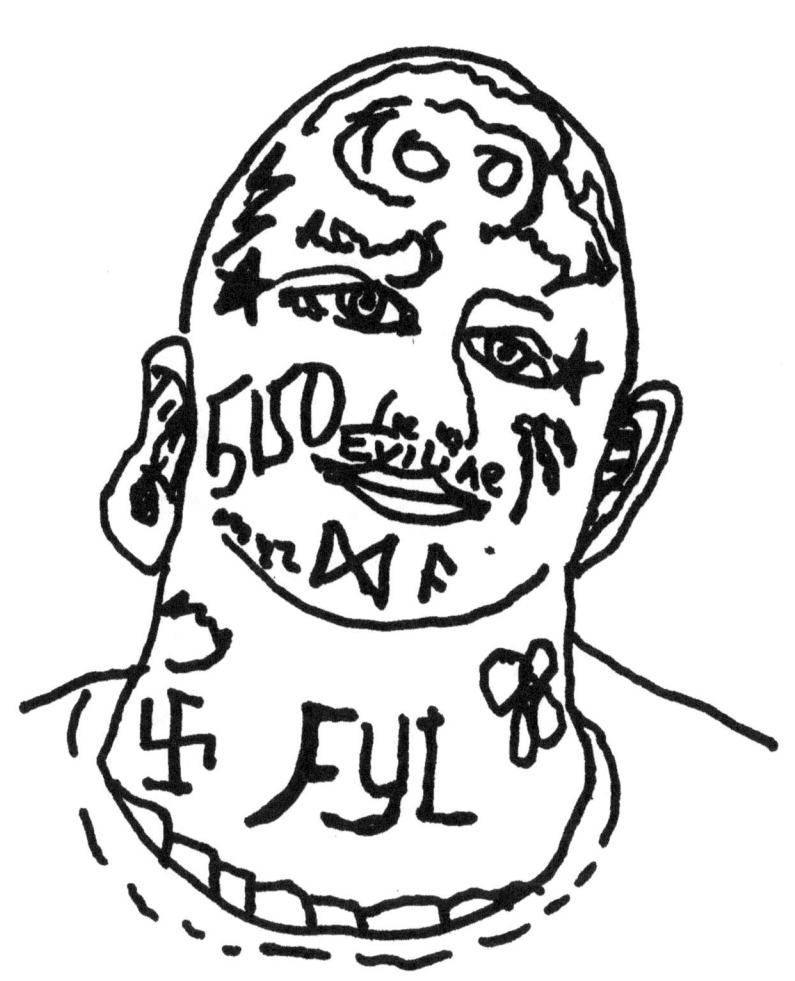

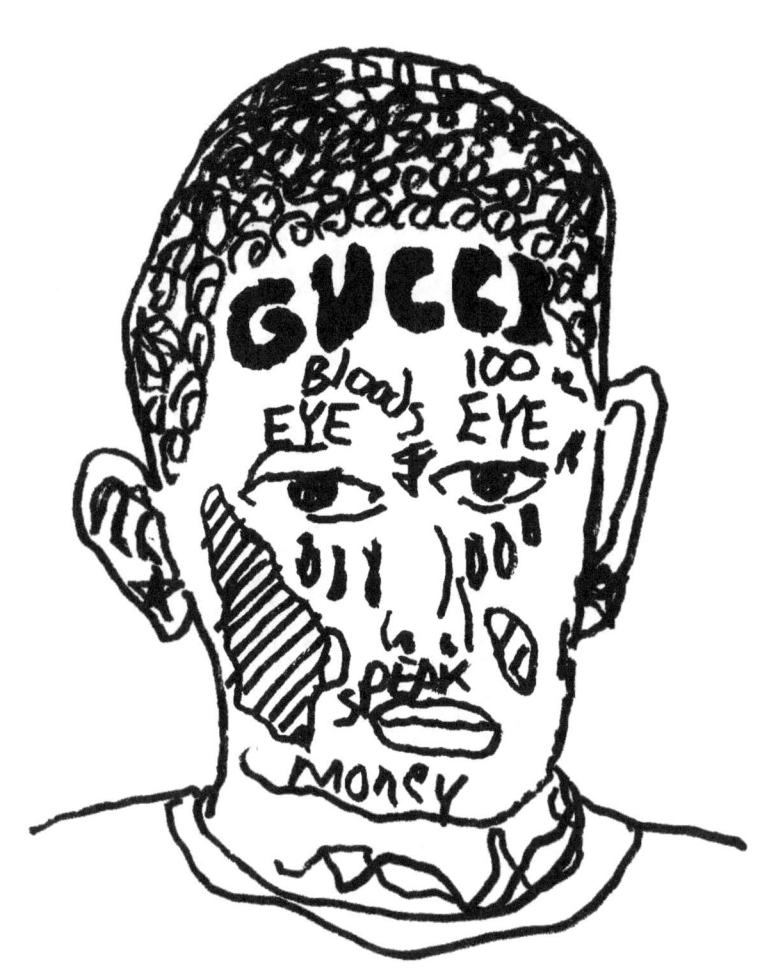

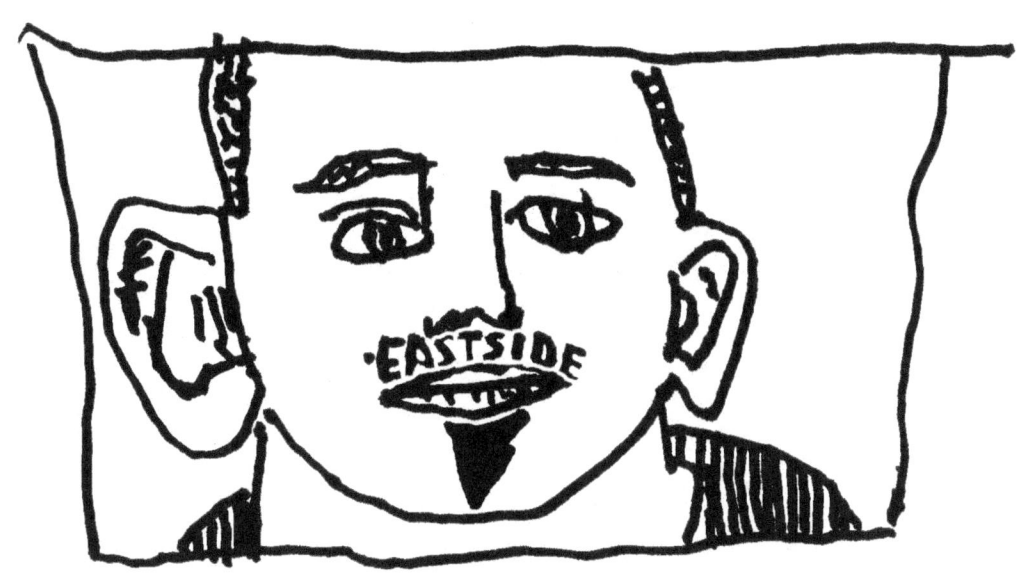

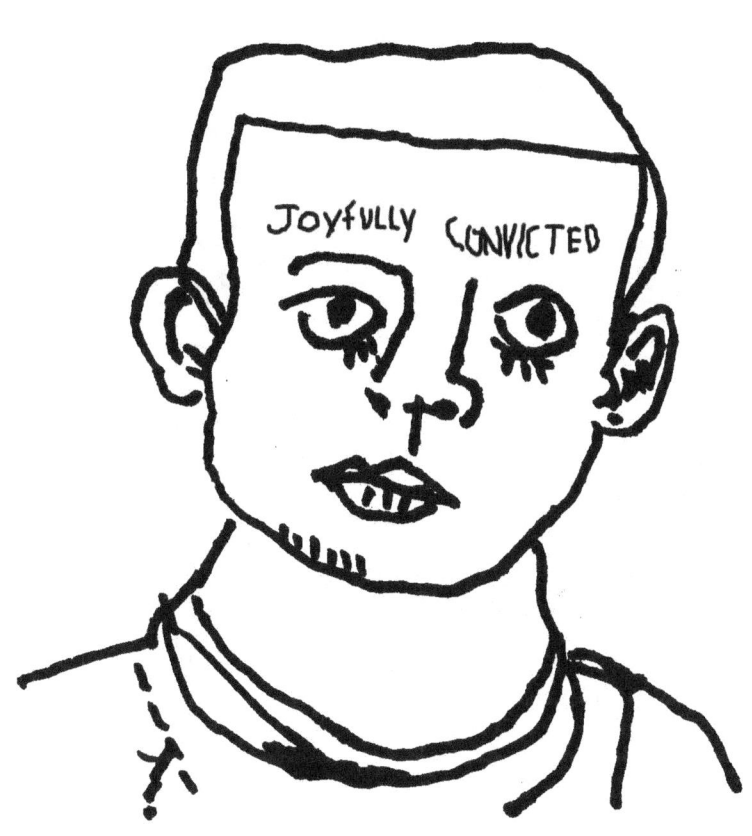

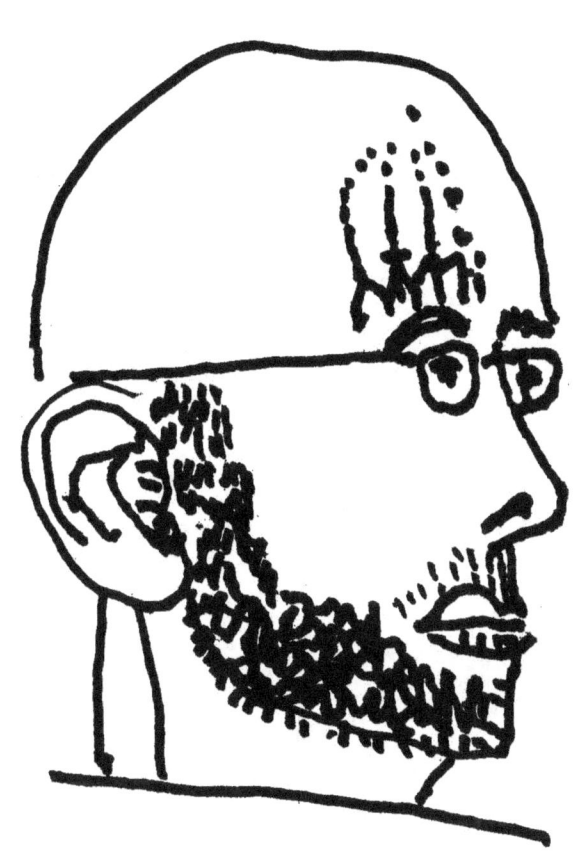

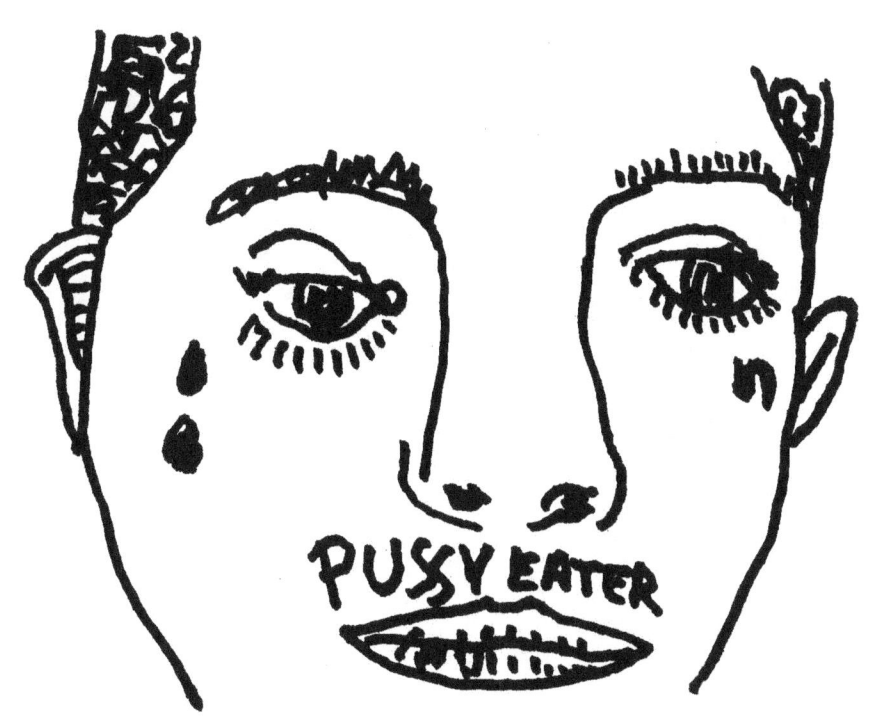

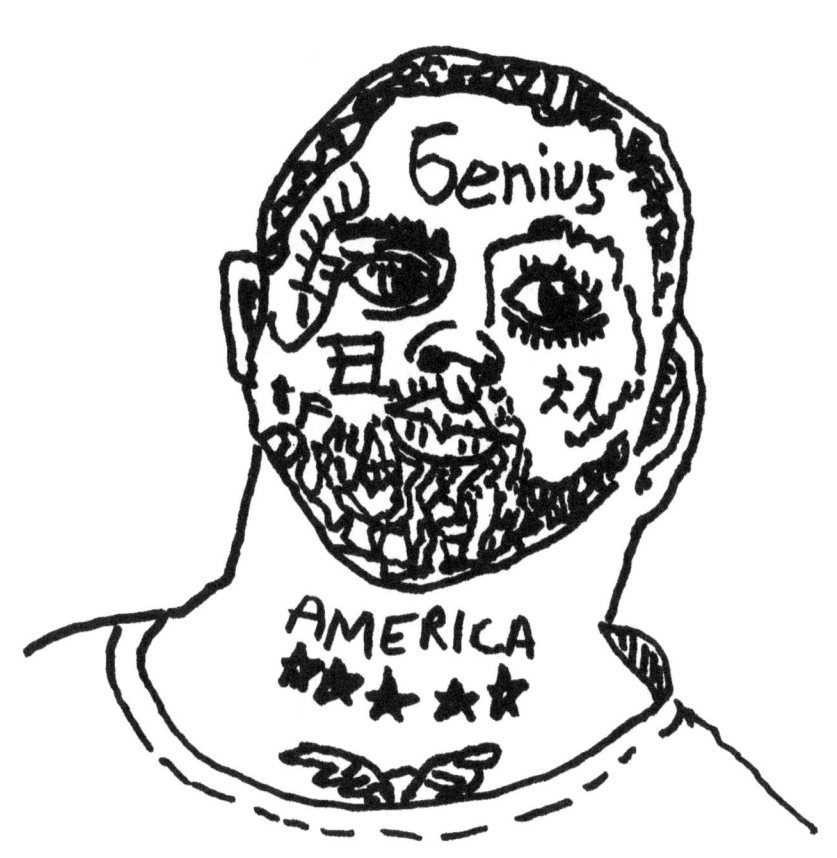

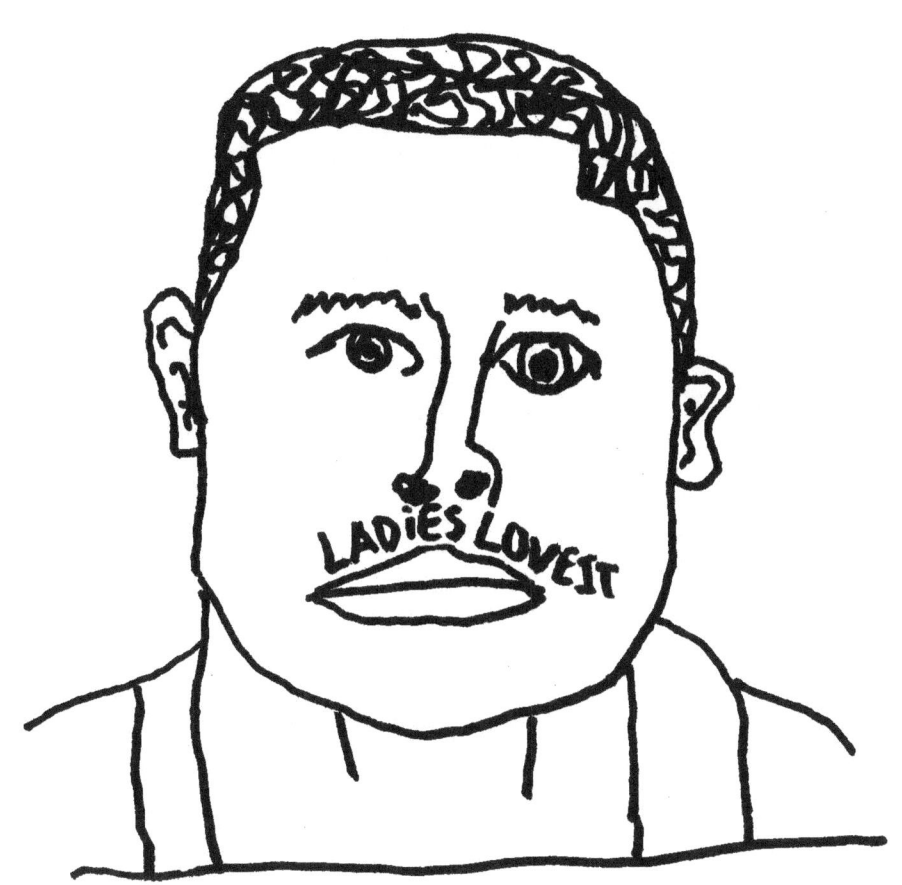

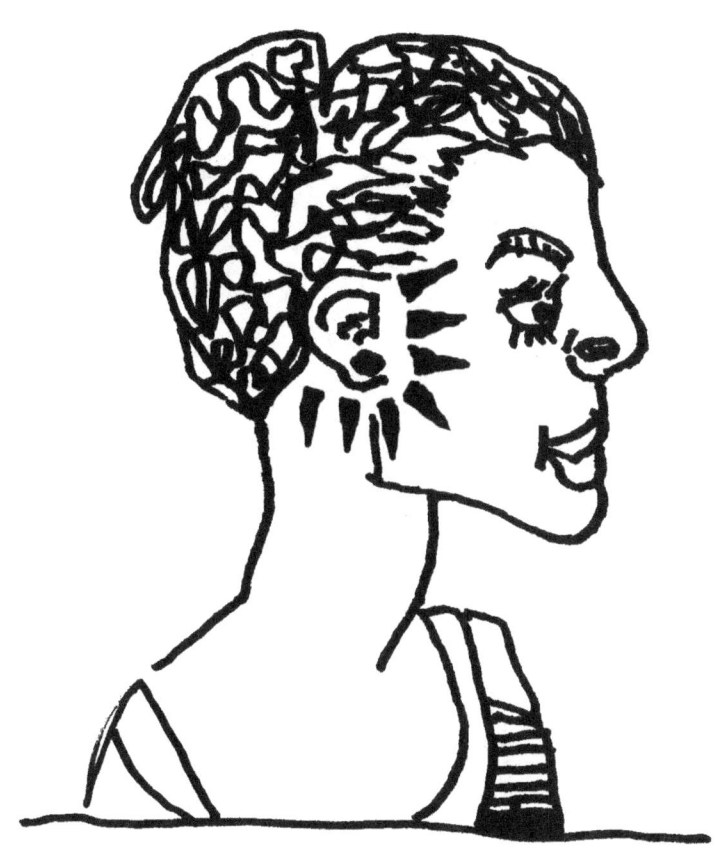

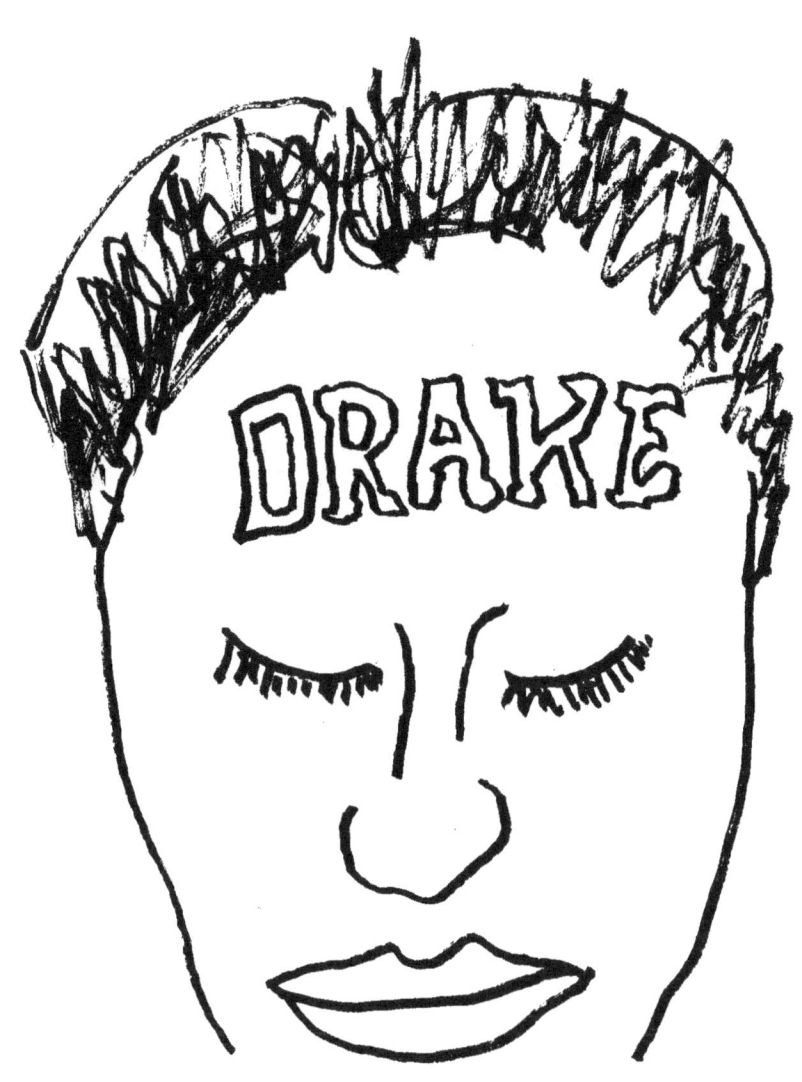

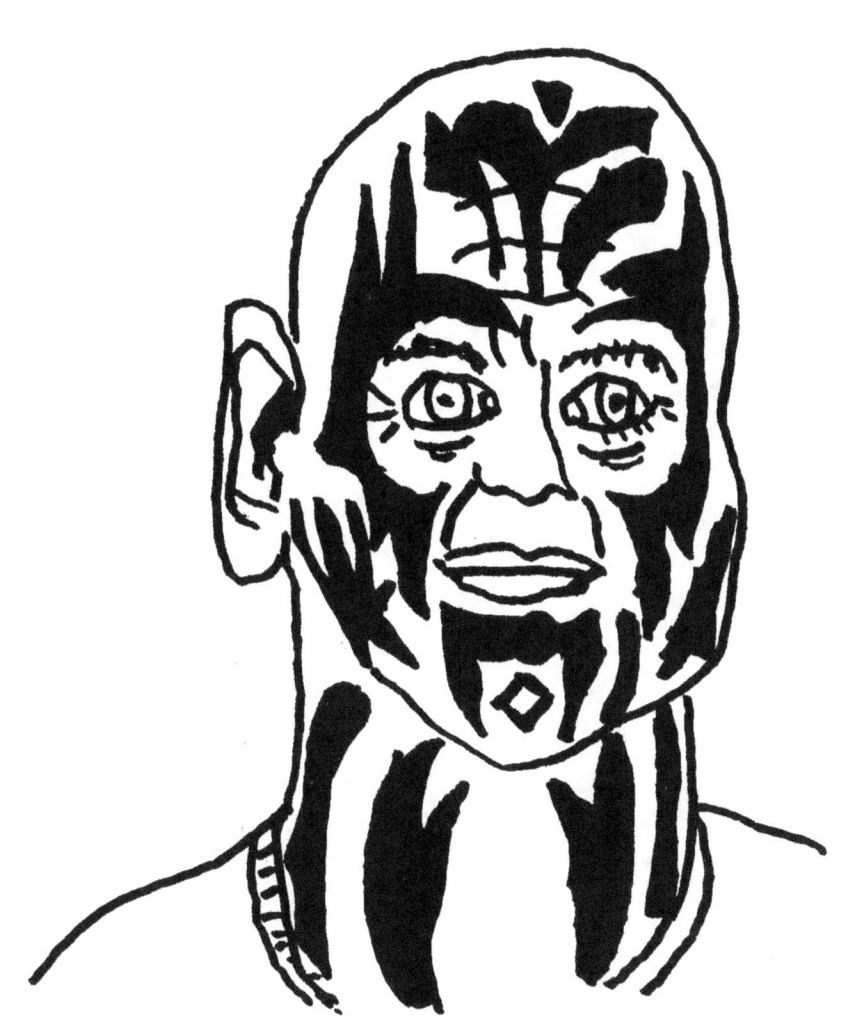

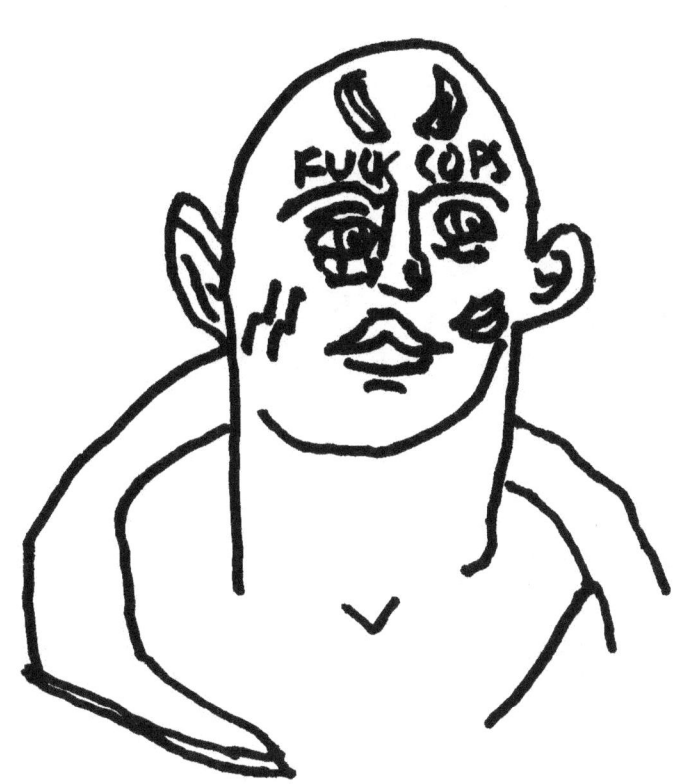

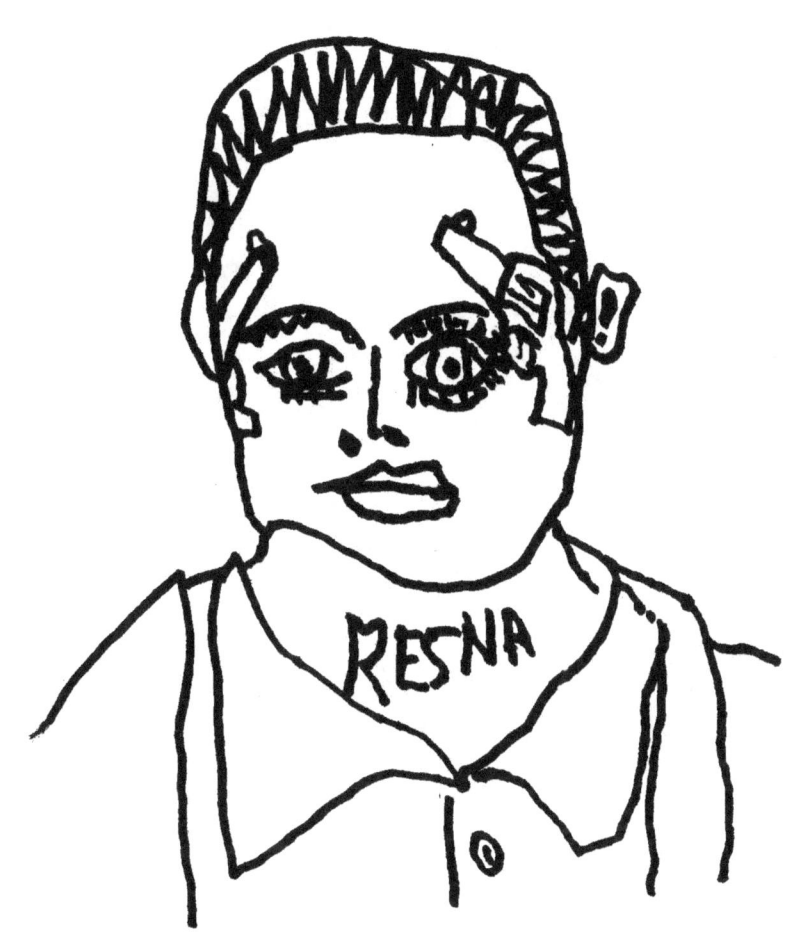

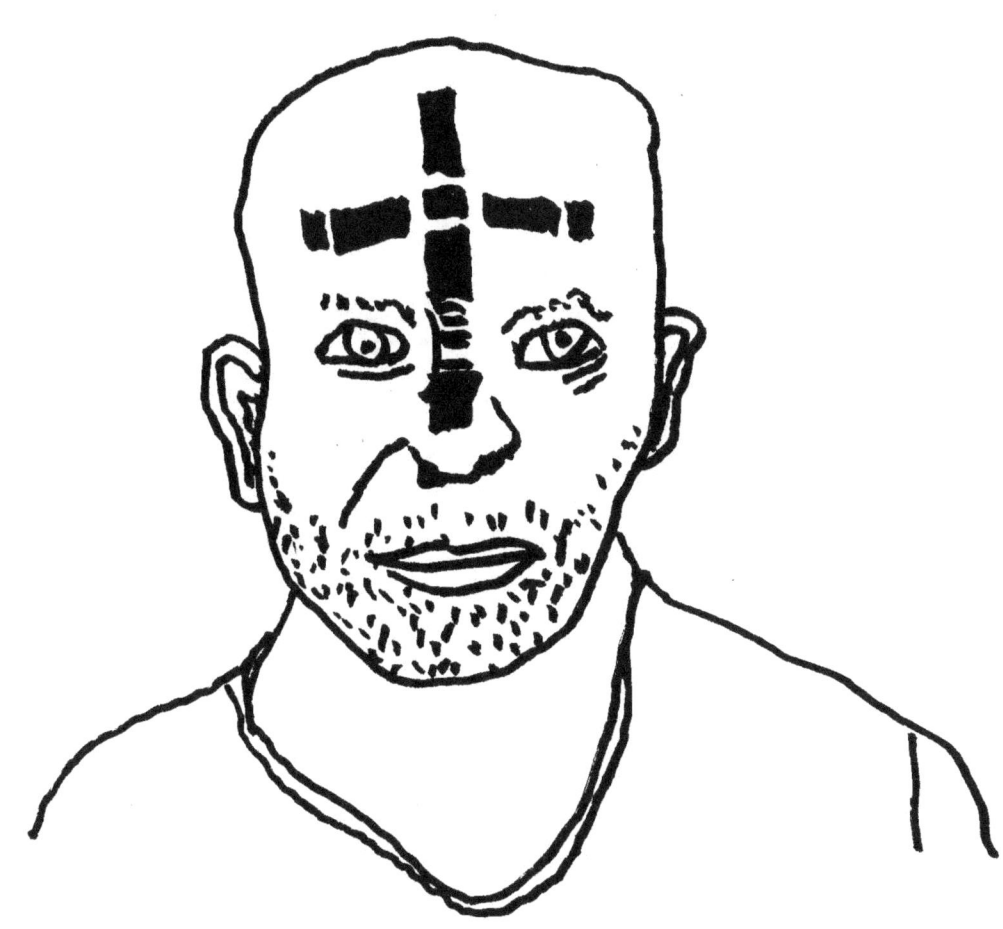

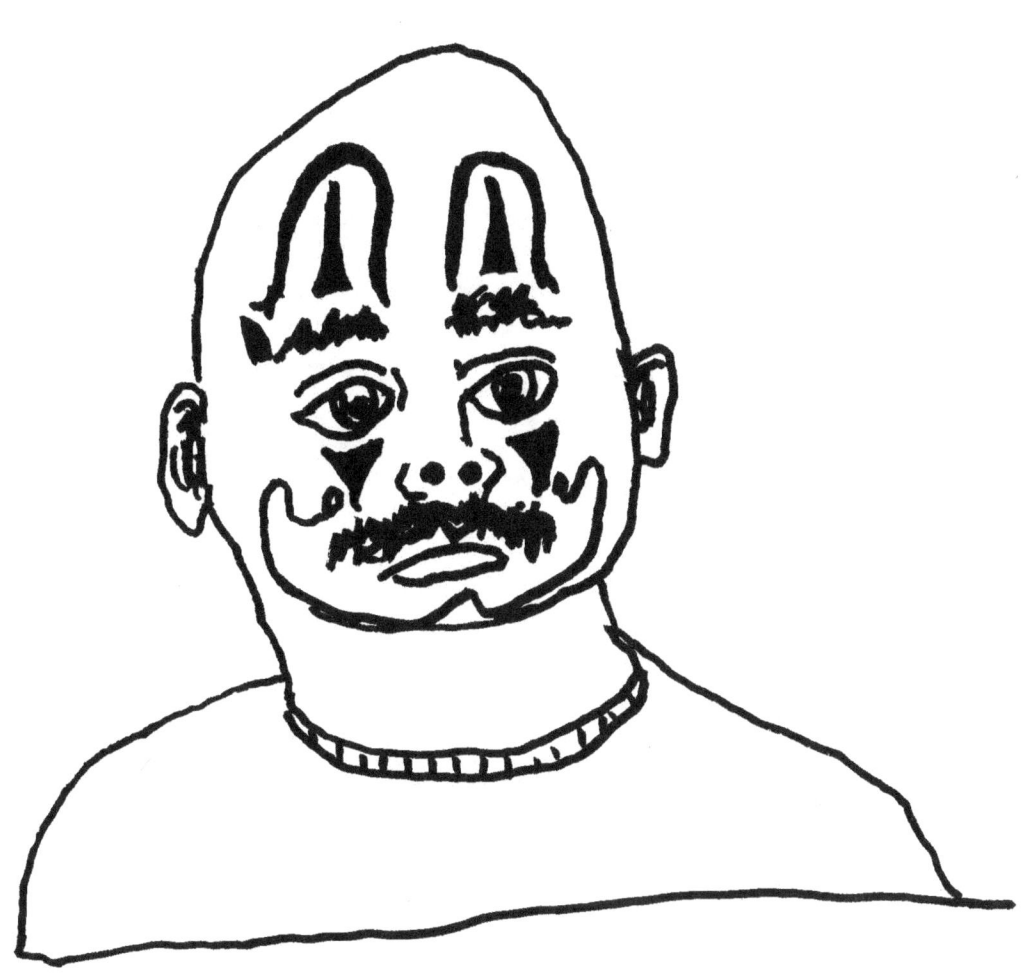

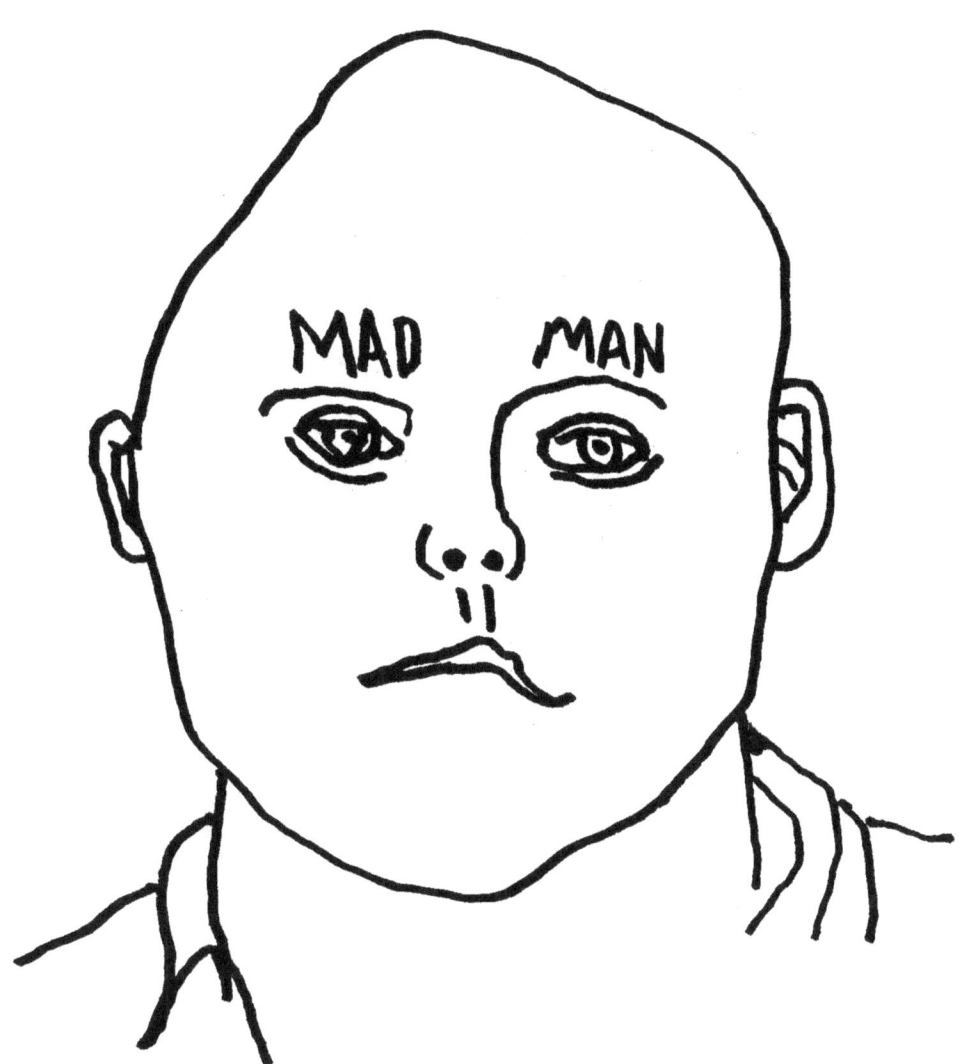

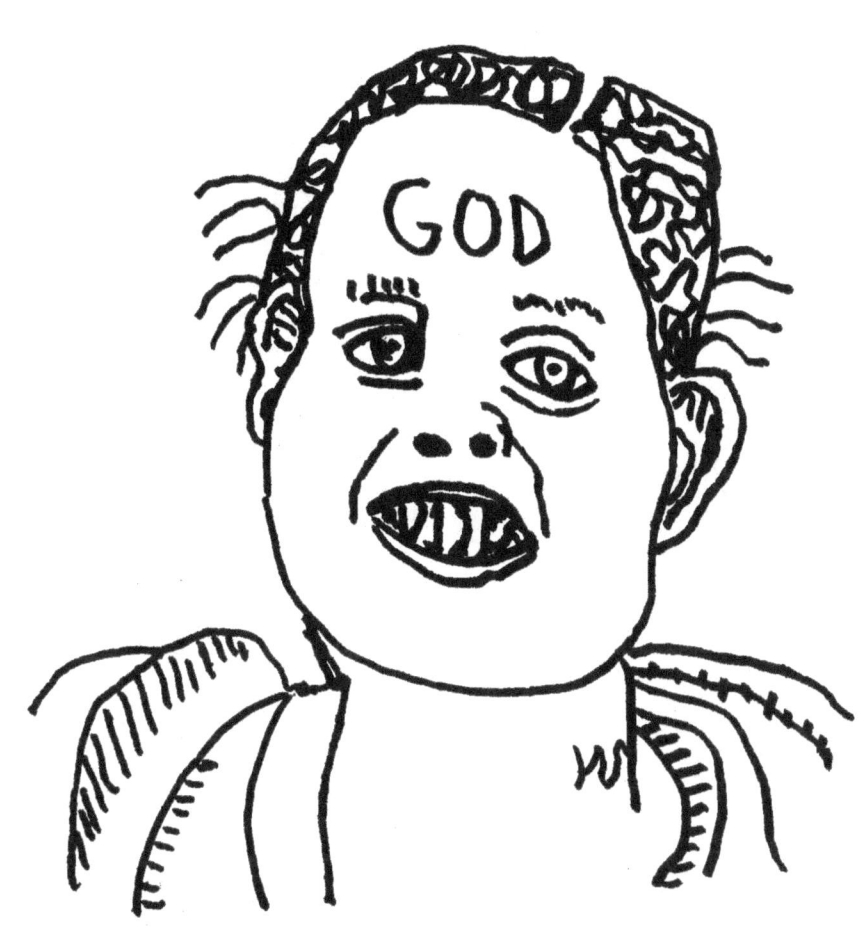

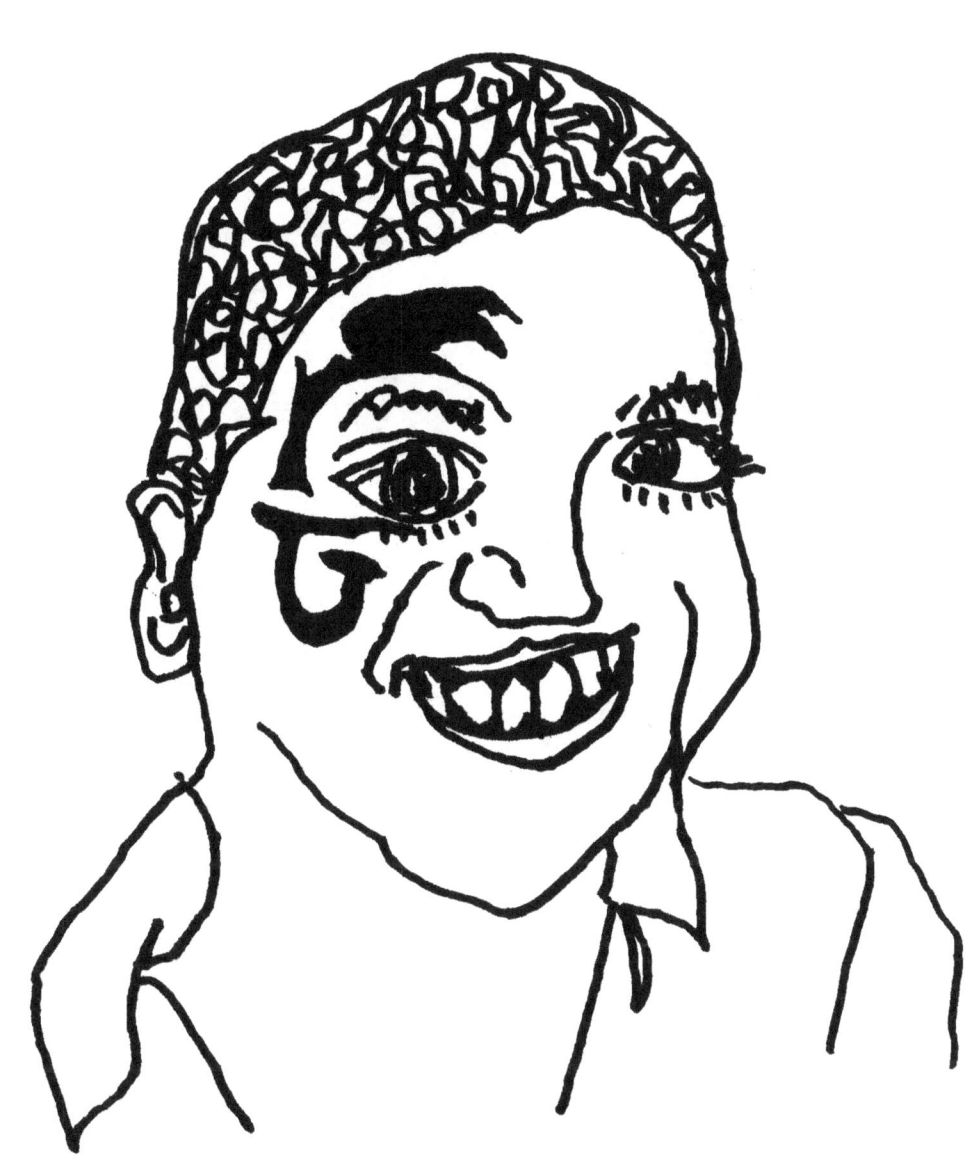

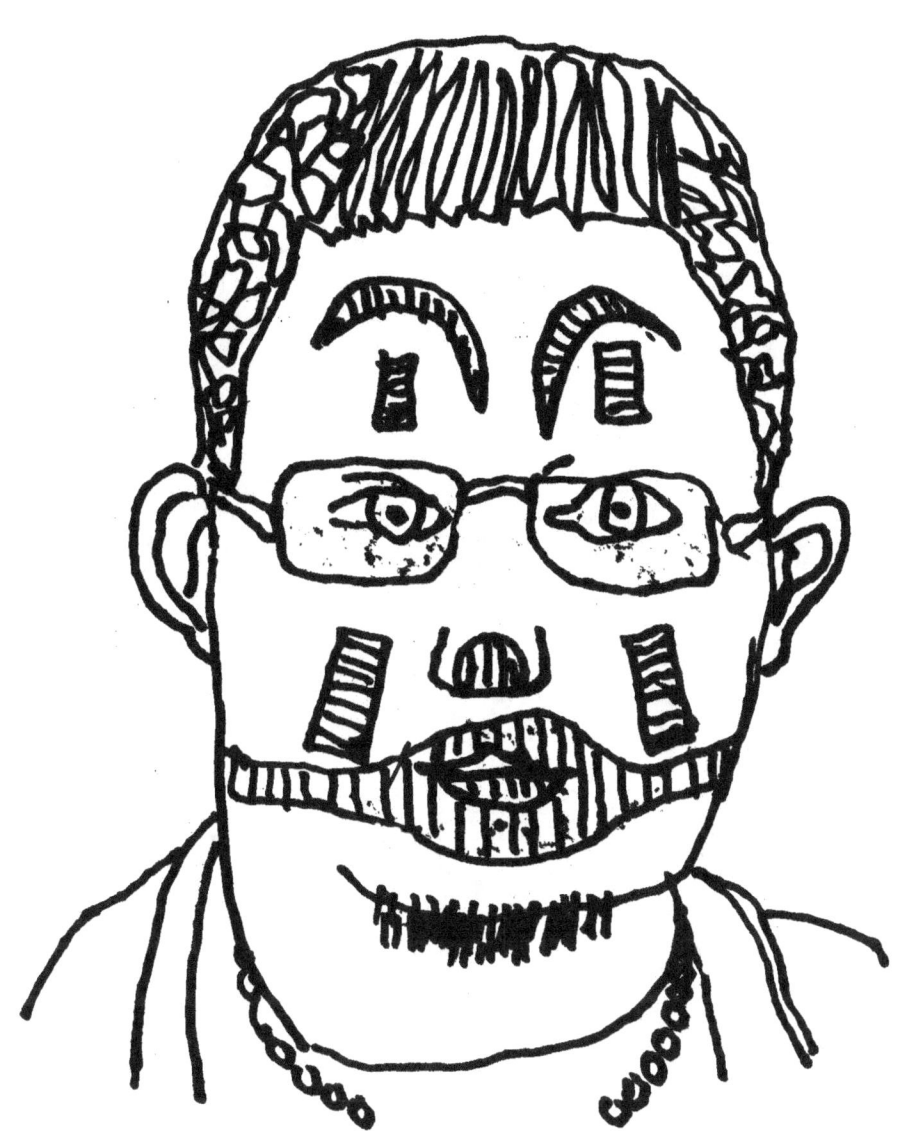

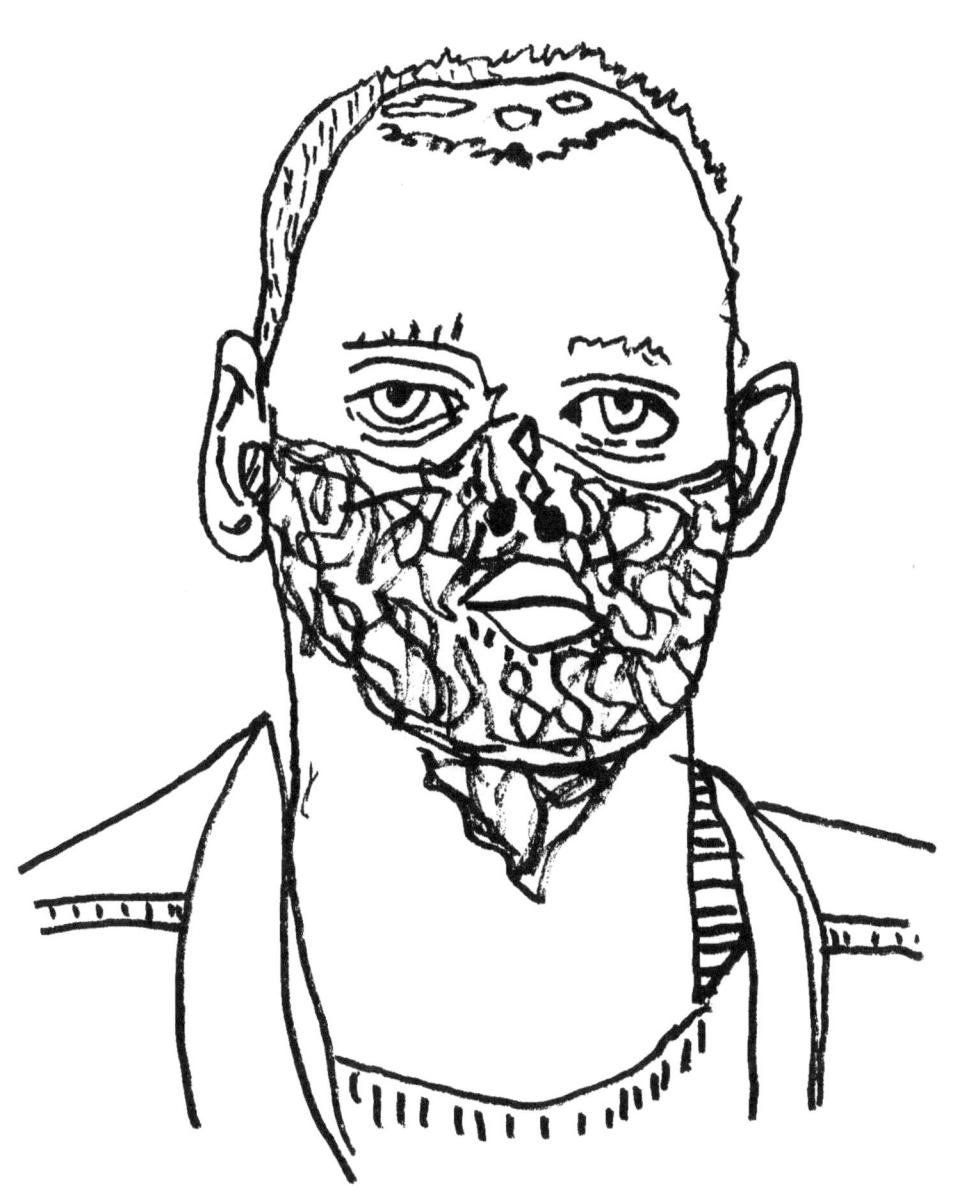

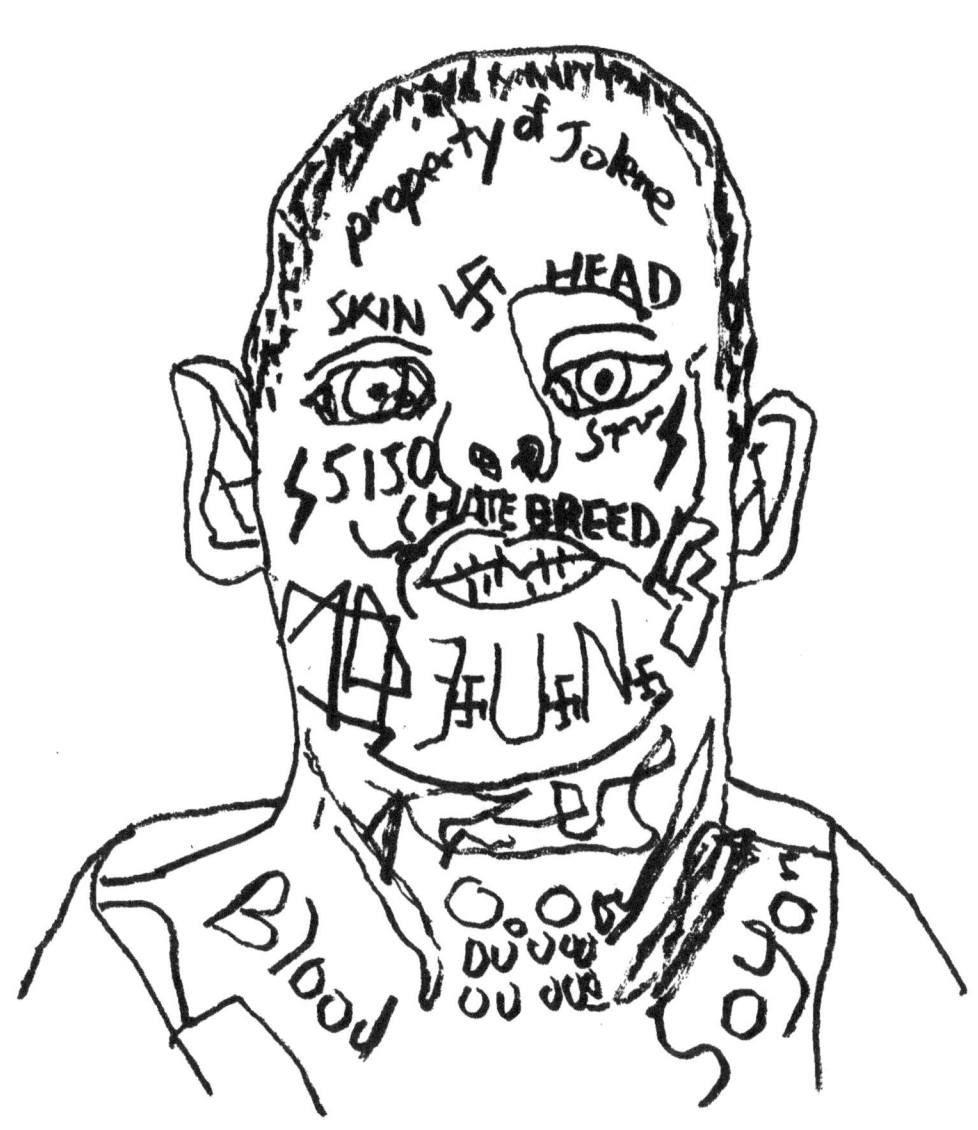

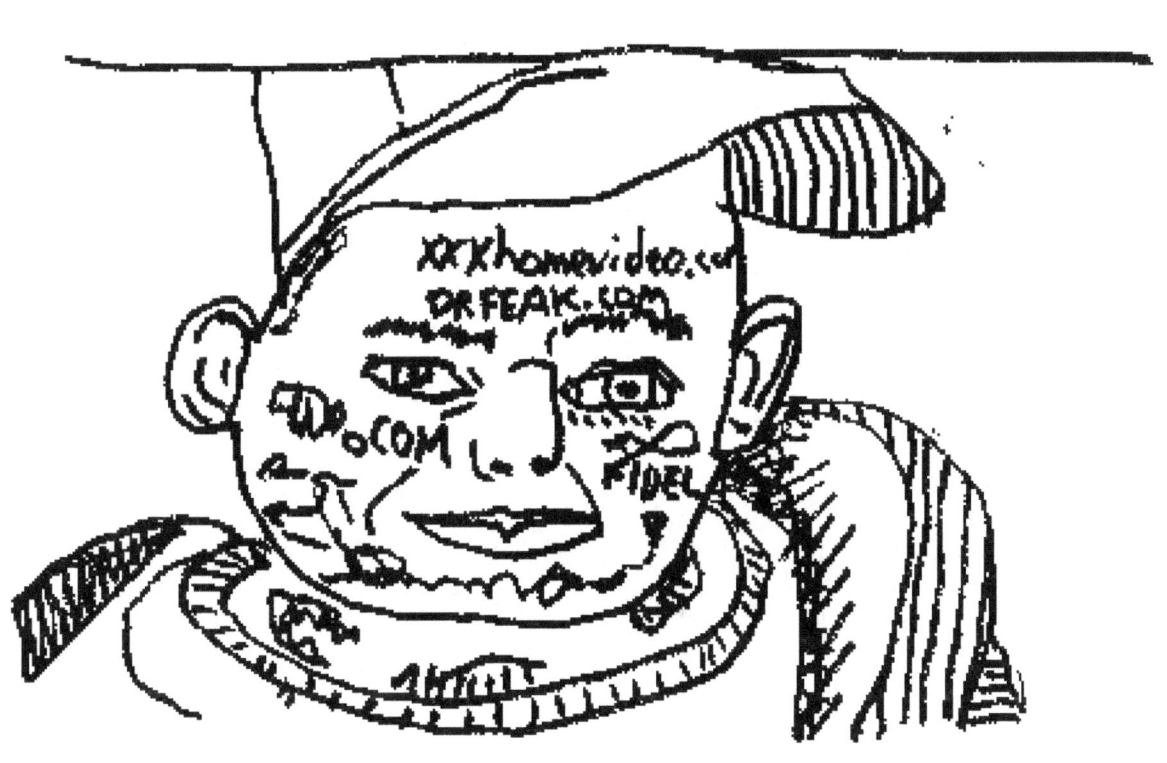

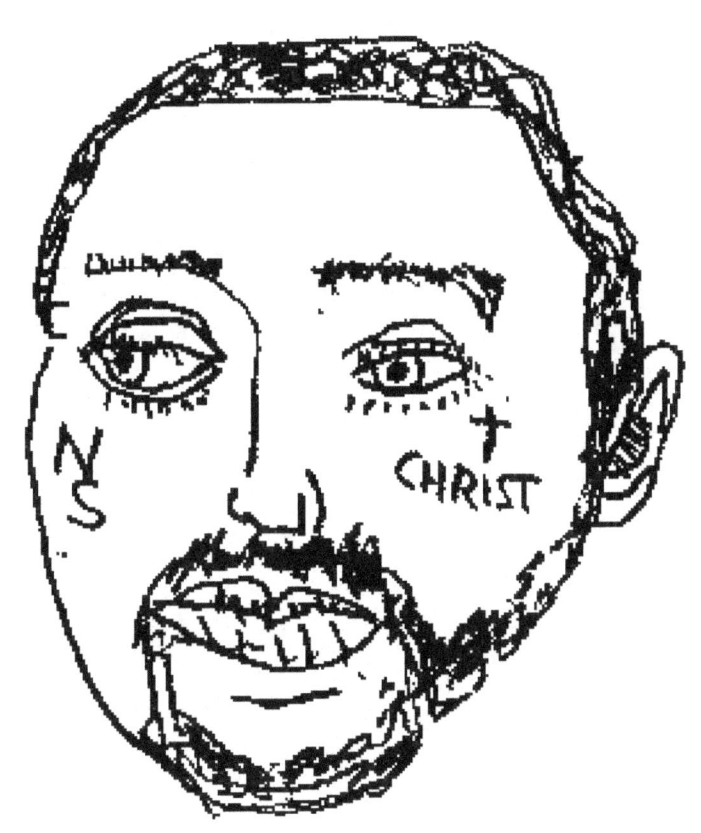

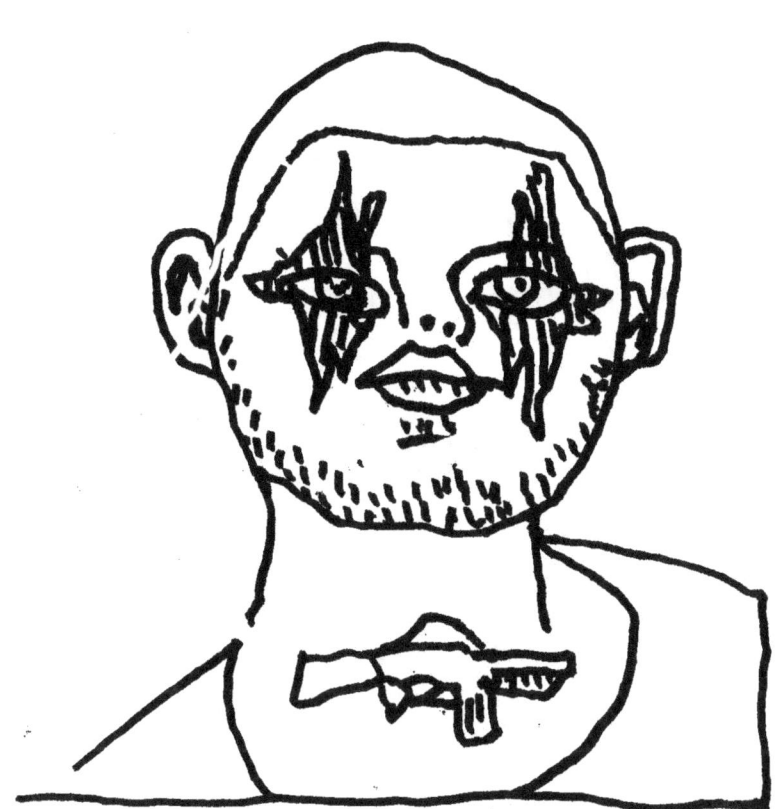

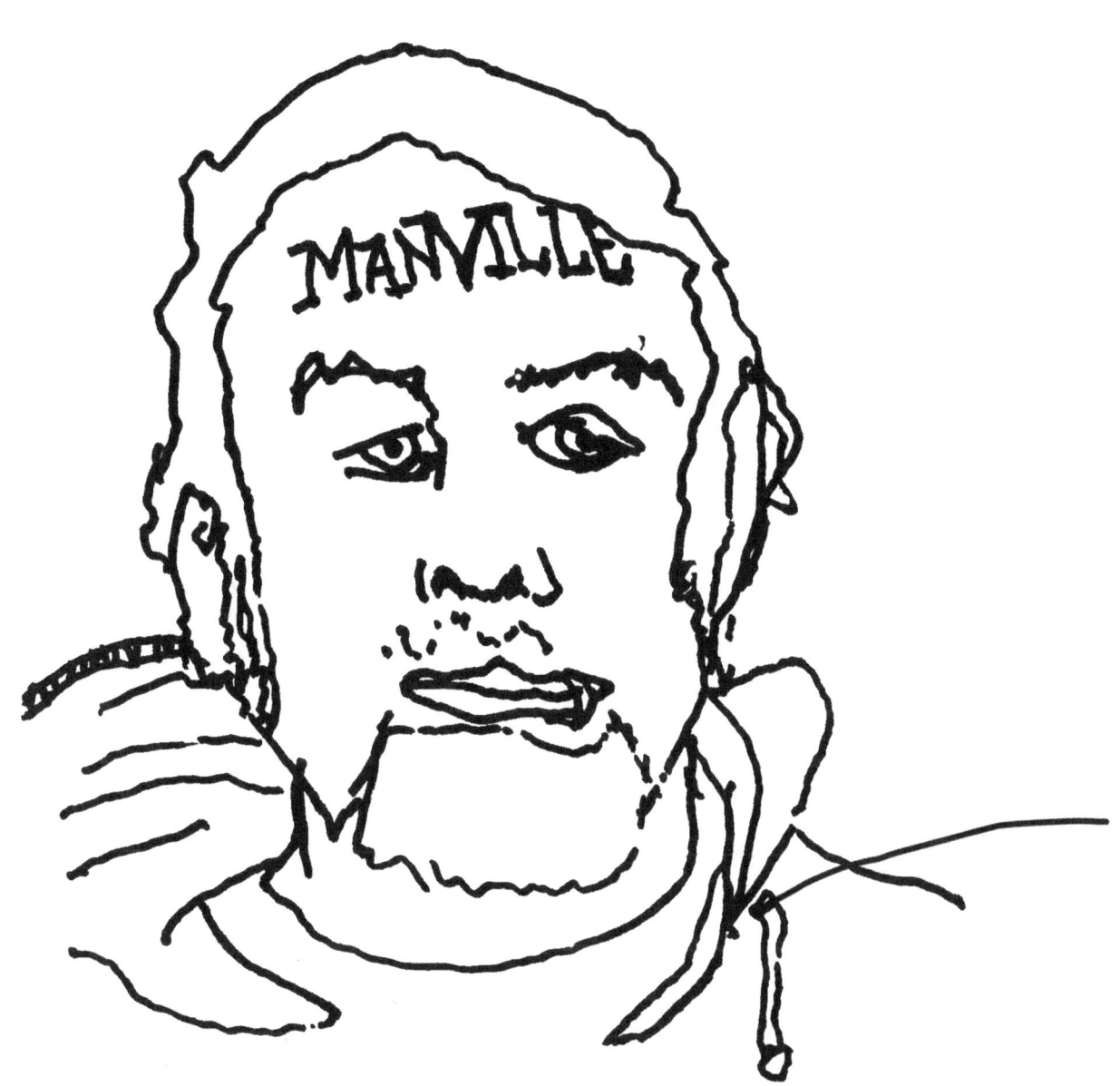

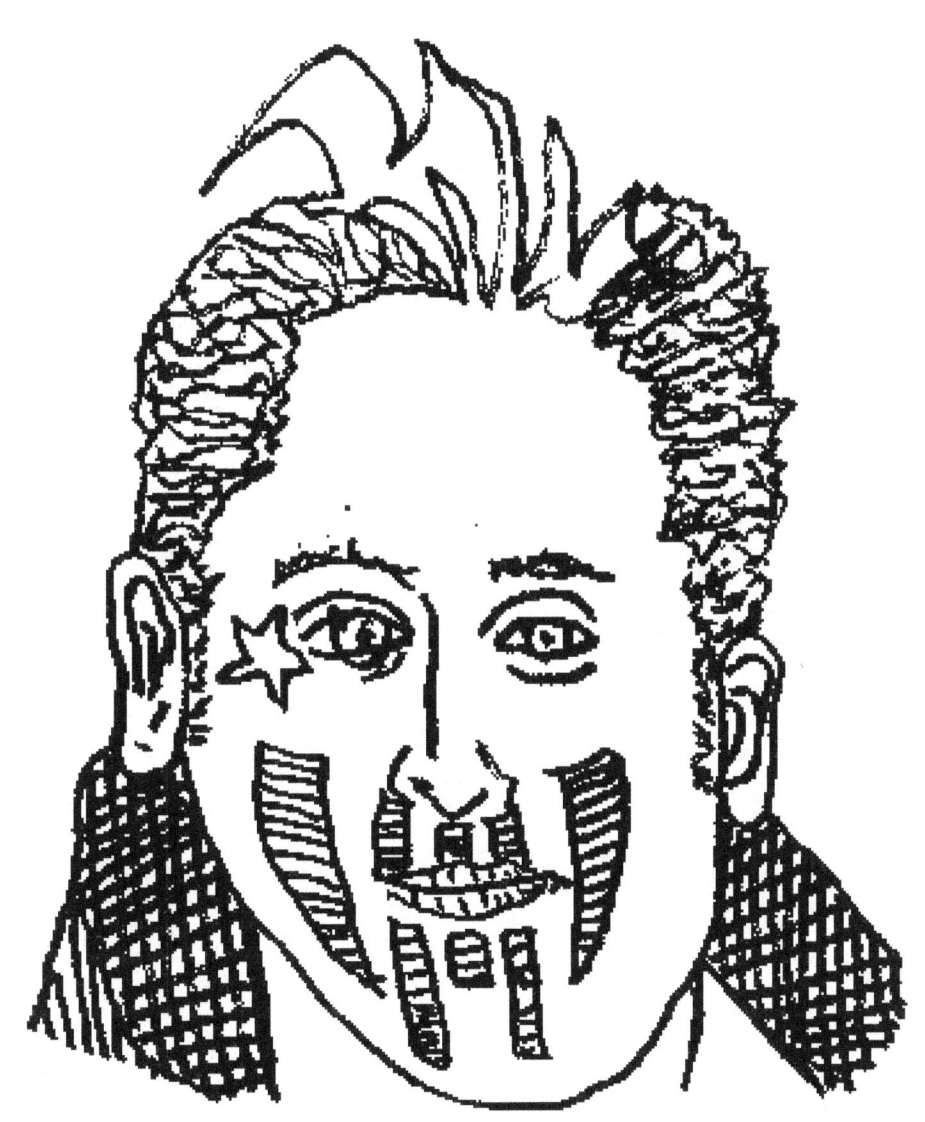

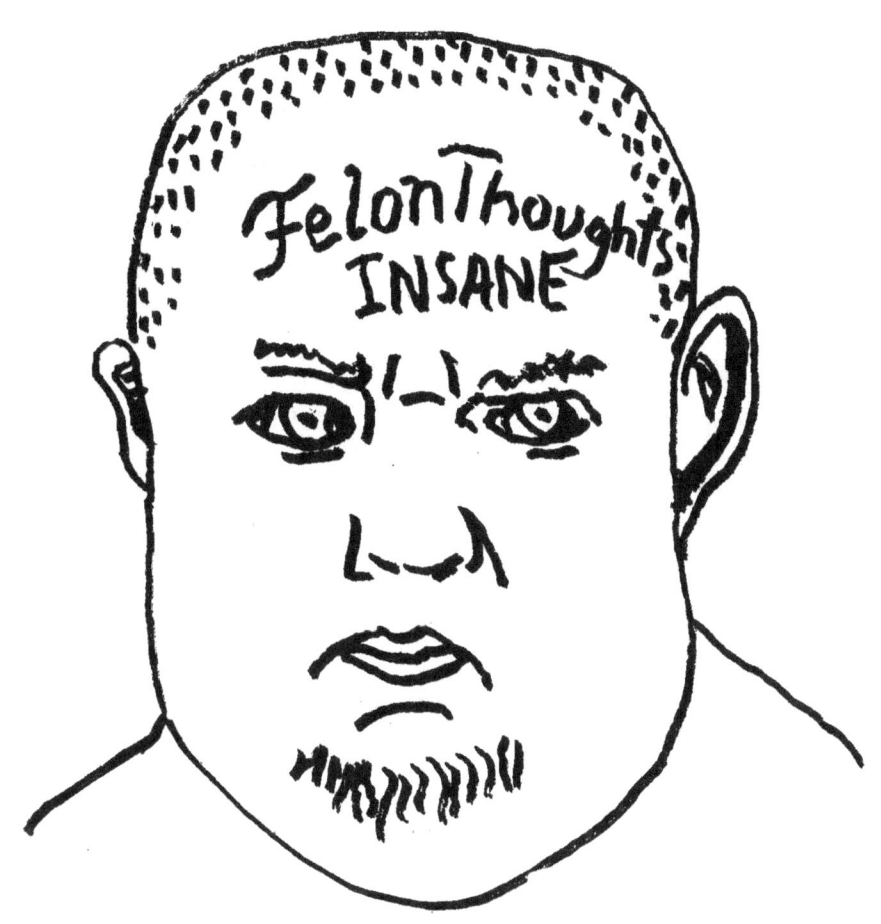

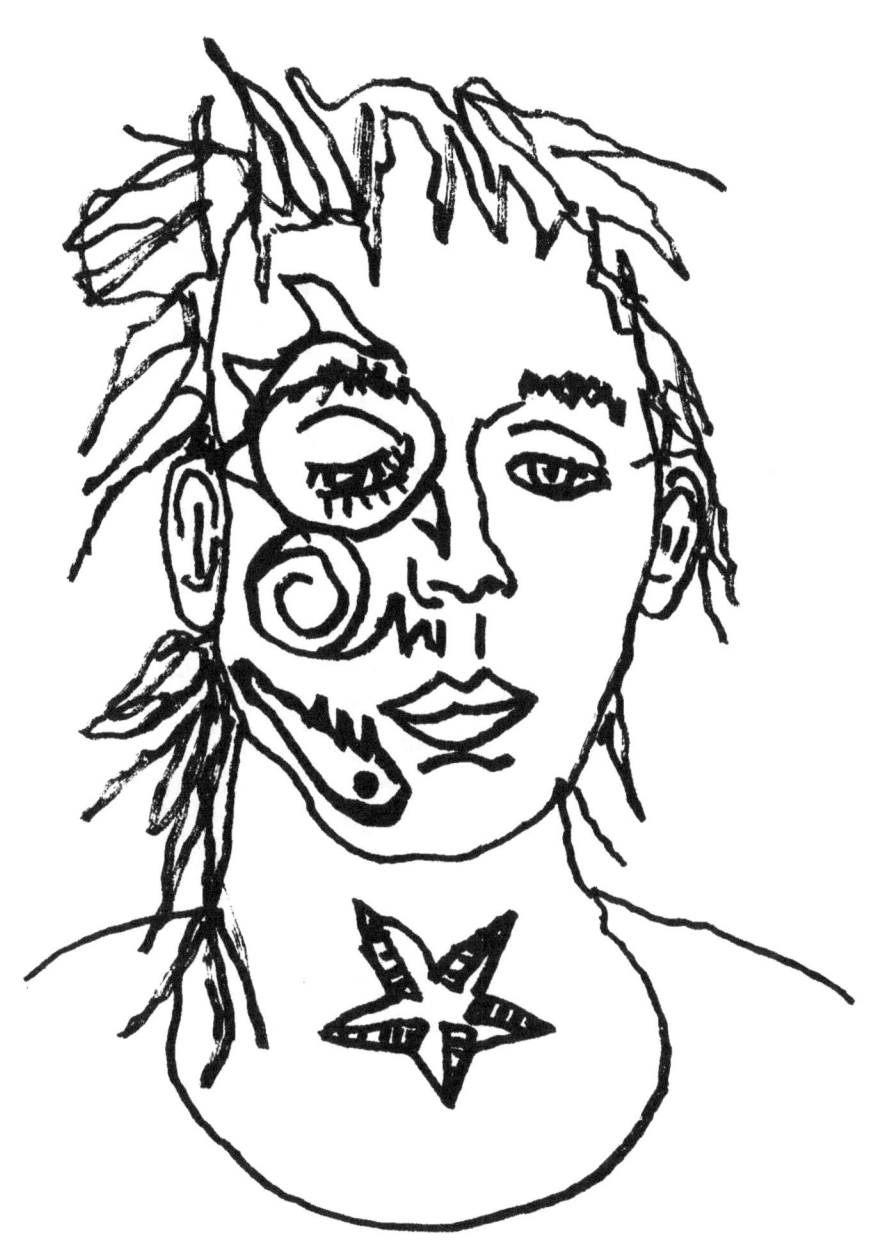

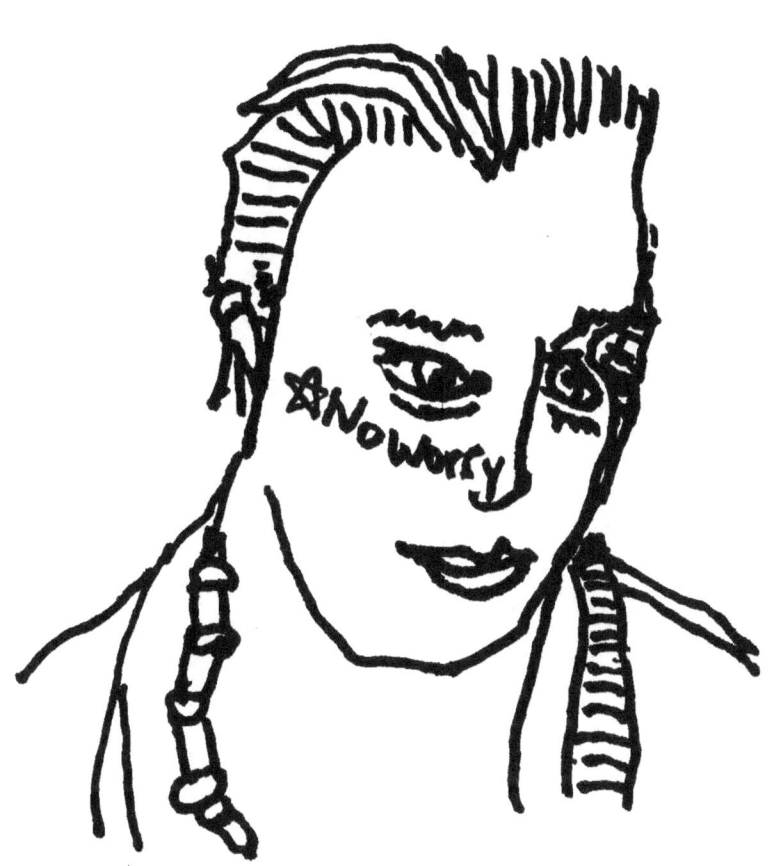

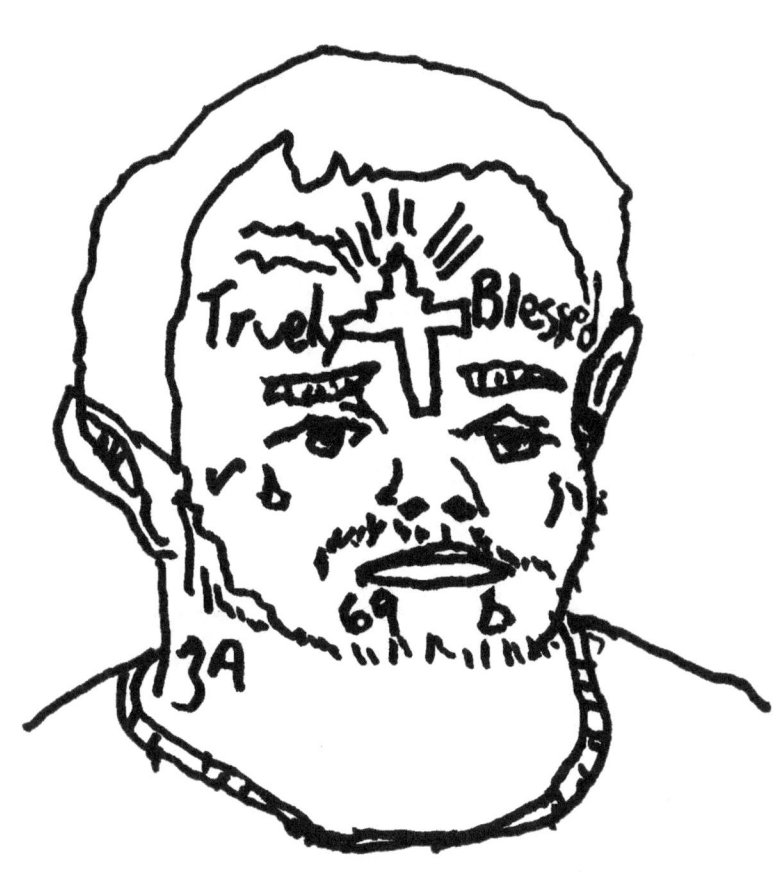

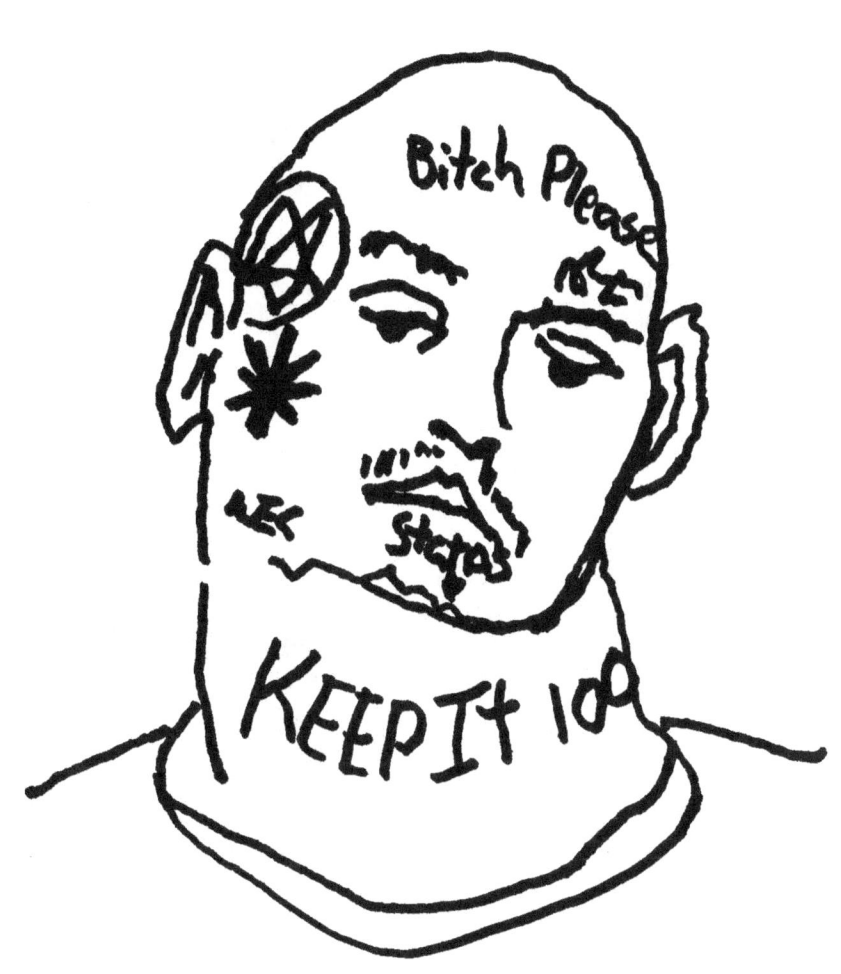

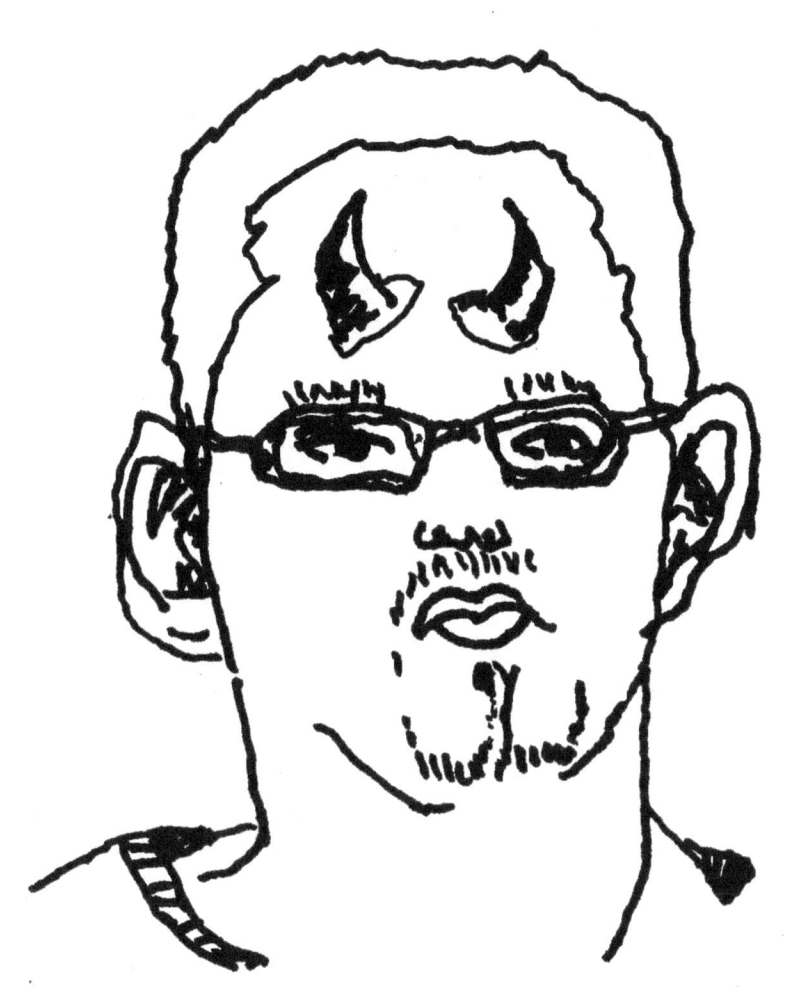

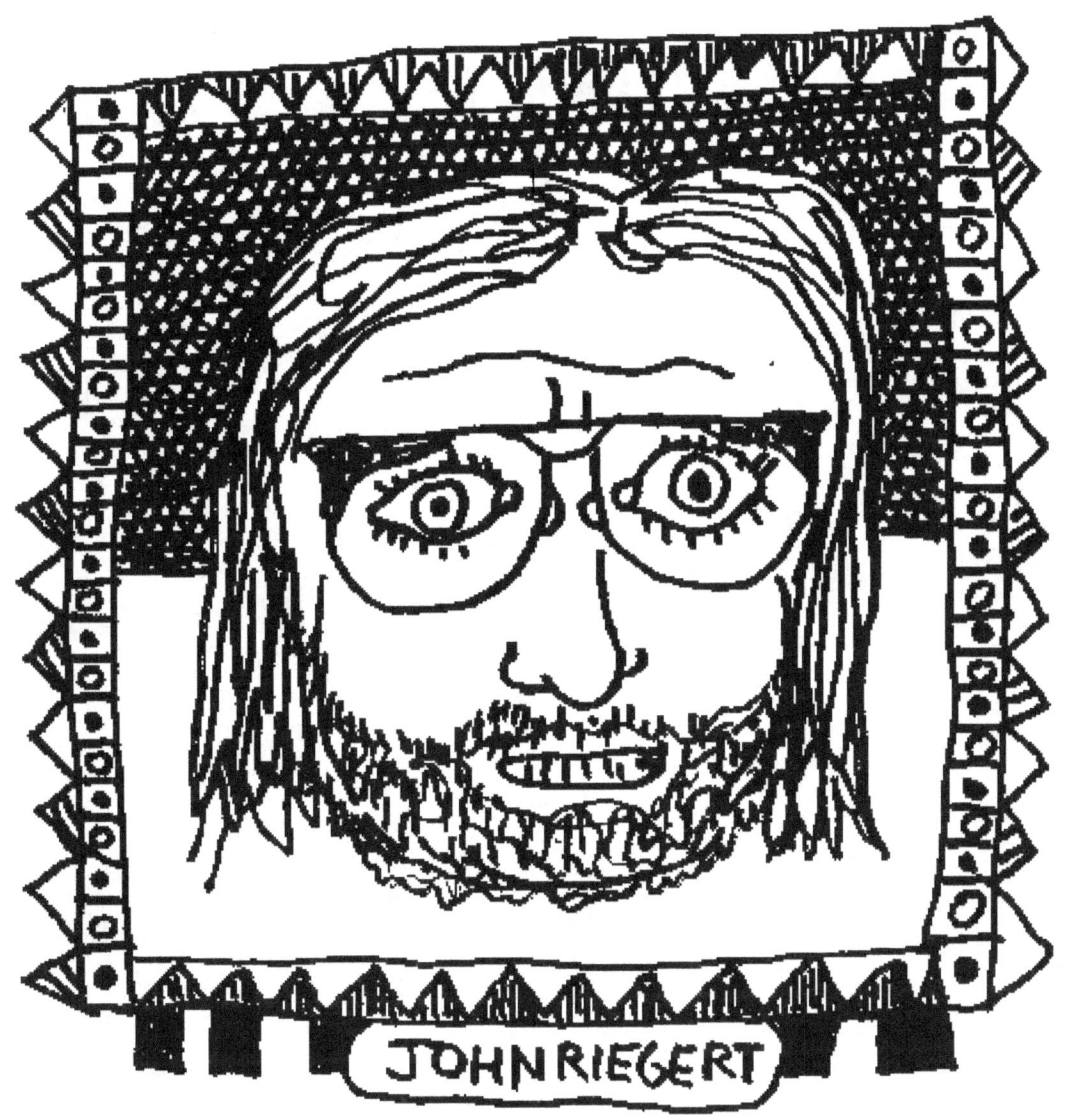

John Riegert is an artist who lives in Pittsburgh PA. He graduated from Carnegie Mellon University with a BFA focusing on multimedia. He can be reached at john@johnriegert.com Check out his website at http://www.johnriegert.com

www.ingramcontent.com/pod-product-compliance
Lightning Source LLC
Chambersburg PA
CBHW080930170526
45158CB00008B/2231